DeKalb County

IN VINTAGE POSTCARDS

POSTCARD HISTORY SERIES

DeKalb County

IN VINTAGE POSTCARDS

Sue Ellen Owens and Megan Milford
DeKalb Historical Society

ARCADIA

Copyright © 2001 by DeKalb Historical Society.
ISBN 0-7385-1401-2

Published by Arcadia Publishing,
an imprint of Tempus Publishing, Inc.
2 Cumberland Street
Charleston, SC 29401

Printed in Great Britain.

Library of Congress Catalog Card Number: 2001093526

For all general information contact Arcadia Publishing at:
Telephone 843-853-2070
Fax 843-853-0044
E-Mail sales@arcadiapublishing.com

For customer service and orders:
Toll-Free 1-888-313-2665

Visit us on the internet at http://www.arcadiapublishing.com

CONTENTS

ACKNOWLEDGMENTS

This book is a collaborative effort of the staff of the DeKalb Historical Society (DHS). Selections from the Joe Lee Collection purchased several years ago by DHS form the core of this publication along with other postcards donated or solicited for this project. The book has evolved out of the time and commitment dedicated to the project by all involved. Megan Milford, an Agnes Scott College student and the Joyce Cohrs Intern for the summer of 2001, did the yeoman's job of scanning, inputting, and creating copy to perfection. Thanks to Curtis Branscome of Stone Mountain Park Authority and Albert Martin for loaning additional postcards; to Walter McCurdy, county historian; and Carol Purdy, archives volunteer, for their assistance with this book. Sue Ellen Owens, executive director, provided oversight and editing as well as the vision for the project. In 1997, the first definitive history of DeKalb County was written, marking the 175th anniversary of the county's formation. This publication joins that one in calling forth the proud history of DeKalb. Once a county of mills, quarries, and dairies, DeKalb is now a large urban county replete with service industries, institutions of higher education, and the second largest tourist attraction in the Southeast, Stone Mountain.

INTRODUCTION

Before Fulton County, there was DeKalb County; and before Atlanta, there was Decatur.

DeKalb was established as Georgia's 56th county on December 23, 1822, and is situated on a natural ridge that runs between Atlanta and Athens. The southern boundary is the South River and the northern boundary is the Hightower Trail, a trading path used by Native Americans. The county has 269 square miles. Within its borders are three natural wonders: the Soapstone Ridge, Arabia Mountain, and Stone Mountain. The Soapstone Ridge south of Stone Mountain is an exposed ridge of streatite used by Native Americans of the Archaic period. Stone Mountain is a natural wonder of granite, as is Arabia Mountain. Named after Johann de Kolb, a native of Germany and self-proclaimed baron who aided the colonists in their fight for independence, DeKalb County gave birth to many churches, farms, and schools. The county seat (land lot 246) was named for Stephen Decatur, a naval hero in the War of 1812. In 1921 Decatur was incorporated as a city, bearing the motto of "a place of homes, schools and churches." While this motto officially belongs to the city of Decatur, in an historical sense it is representative of all of DeKalb County.

Early settlers of DeKalb were of English, Scotch, and Irish descent and came from Virginia and the Carolinas. Many of them were poor and not highly educated; the majority were hardworking farmers who lived in log cabins and owned few, if any, slaves. DeKalb never operated under the plantation system, and in fact, the two DeKalb delegates to the convention on secession voted against seceding from the Union. Nevertheless, in July of 1864, DeKalb had its first taste of the Civil War. Gen. James B. McPherson with Gen. William T. Sherman's army was under orders to destroy the Georgia railroad and occupy Decatur; the troops began first at Clarkston then moved through Stone Mountain toward Atlanta, breaking tracks as they went. Soldiers occupied Decatur Cemetery, from the courthouse square toward the site now home to Agnes Scott College, and along Sycamore Street. Much of the battle of Atlanta actually took place in DeKalb County, along DeKalb Avenue east of the city proper.

During the early years, industries in DeKalb County included granite quarries, dairy farms, and cotton mills. The land near the South River produced 1,000 or more pounds of cotton per acre, and the county was one of the largest milk producers in the Southeast. Large farms supplied vegetables throughout the region. Development in DeKalb in those early years occurred mainly along the rivers; after 1845, development extended along the railroad lines from the county seat of Decatur east to Stone Mountain and southeast to Lithonia. The first three cities established in DeKalb County were Decatur, Stone Mountain, and Lithonia. The creation of the DeKalb waterworks signaled the first county-owned water system south of Virginia. Commissioner Scott Candler, known as "Mr. DeKalb," was the major force behind the establishment of the waterworks. DeKalb

began pumping water to most of the county in 1943; by the time Candler left office in 1955, the county waterworks served every area of the county except those residents who chose to maintain their own systems. One of the major benefits of the DeKalb waterworks was the 1945 establishment of the General Motors plant in Doraville; it remains DeKalb's largest industrial force to date.

DeKalb was the site of a military base as well. Camp Gordon was established near Chamblee in 1917 for training of troops during World War I. After the war ended, the camp was closed for 23 years. DeKalb County purchased the property in 1940, and in 1943, Camp Gordon reopened as a naval air station. In 1960, the county took over the operation, which is now known as Peachtree DeKalb Airport.

Over the years, Columbia Seminary, Oglethorpe University, and Emory University, all chose DeKalb County as their homes, often over other sites, and Agnes Scott College was founded in DeKalb County. The historic neighborhood of Druid Hills was established in 1905 with the aid of famed landscape architect Frederick Law Olmsted, and Avondale Estates was planned as a community of fine homes located around a central lake. African-American communities such as Scottdale, Shermantown, and Lynwood Park developed with strong histories. In addition to enjoying their neighborhoods, DeKalb residents have enjoyed recreational pursuits at East Lake and Silver Lake, as well as Stone Mountain, a natural wonder of granite upon which is carved a memorial to Confederate leaders Robert E. Lee, Thomas "Stonewall" Jackson, and Jefferson Davis. The sculpture was dedicated in 1971 and is a major tourist attraction, exceeded only by Disney World in Orlando.

Over the years, DeKalb County has enjoyed a number of successes. The industrial and educational establishments in the county have contributed to a steady influx of new residents, who have helped build DeKalb into a thriving community of the 21st century without sacrificing the charm of years past. In 1853, when portions of DeKalb were carved out to created Fulton County, the county had a population of 14,000 people, most of whom were farmers. In 2001, DeKalb County has a population of over 690,000. It also has the second largest population of middle- to high-income African Americans in the country and is now an urban county far removed from the days of truck farms and dairies.

One

LANDMARKS

DeKalb County landmarks and events hold a special place in the hearts of area residents. The Old Courthouse is the most recognized landmark in the county and serves as a community gathering spot. Boating on area lakes and visiting state fairs provide residents with entertainment.

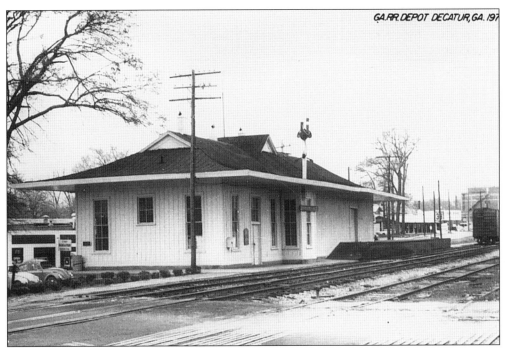

This *c.* 1975 photograph depicts the Decatur depot. Though CSX trains still run frequently along the College Avenue rails, the unused depot has fallen into disrepair. Purchased by the City of Decatur in 2001, the depot will be moved and restored.

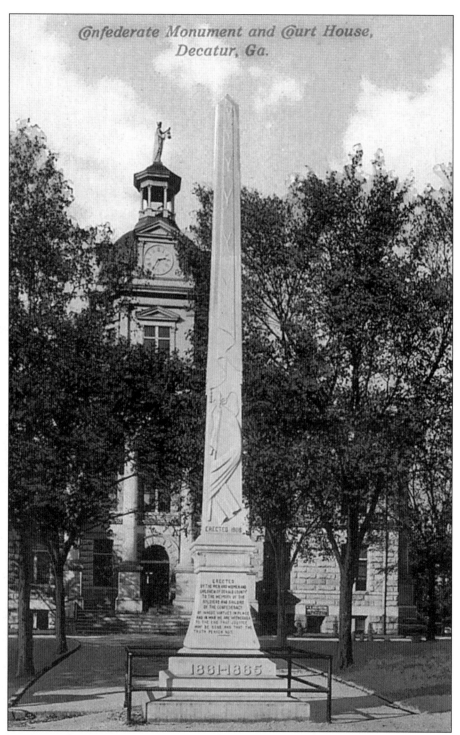

Confederate Monument and Court House, Decatur, Ga.

The Confederate Memorial was erected in 1908 to honor the soldiers of the Confederate Army. It stands on the courthouse square directly behind the Old Courthouse. Mary Harris Gay, the author of *Life in Dixie during the War,* raised the funds to establish the memorial.

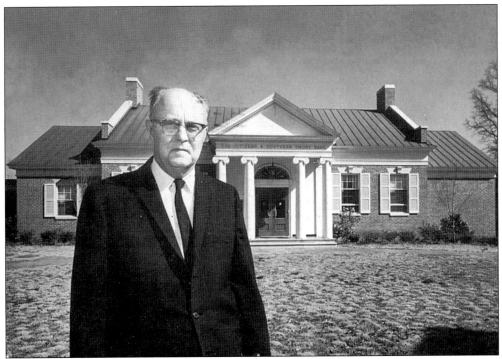

The Citizens and Southern (C&S) Bank was a prominent part of Atlanta life for many years. Pictured above is the Emory branch of C&S Bank and branch president Vann Groover.

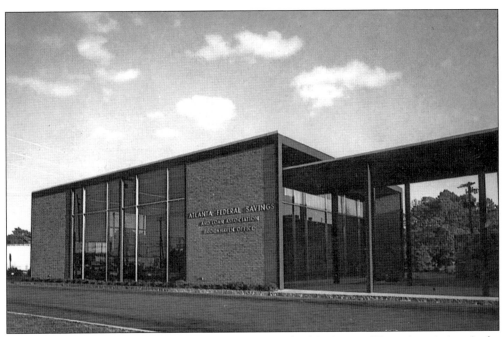

Shown here is the Brookhaven branch of the Atlanta Federal Savings and Loan Association. At the time this image was produced, Atlanta Federal was billed as "Georgia's Largest Savings Institution."

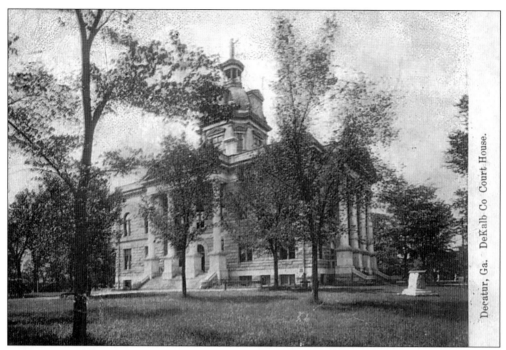

This version of the DeKalb County Courthouse was built in 1898 and was the fourth courthouse to serve the area. This new courthouse was touted as "fireproof" due to its granite exterior; however, a fire gutted the building and destroyed the cupola in 1916. This photograph was taken shortly after the building's construction was completed.

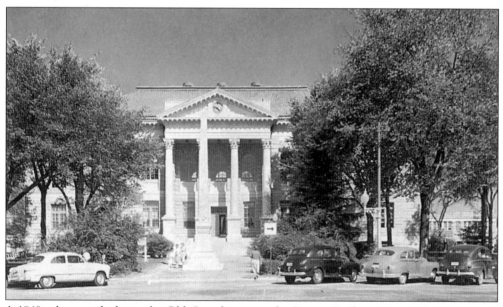

A 1940s photograph shows the Old Courthouse on the Square. Built in 1917 within the granite shell of the former courthouse, this fifth incarnation served DeKalb County until the construction of the current courthouse in 1967. The building is now home to the DeKalb Historical Society, the McCurdy Family Research Center, and the Jim Cherry Museum.

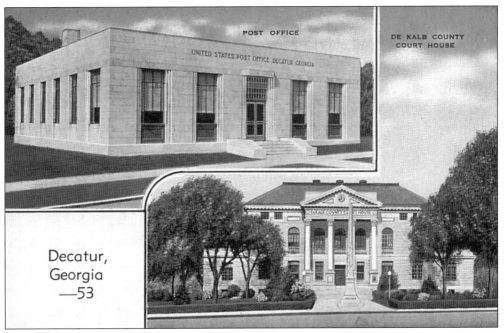

The artistic depiction of the Old Courthouse above includes a drawing of the Confederate Memorial and a rendering of the United States Post Office in Decatur, as it appeared in the 1930s and 1940s.

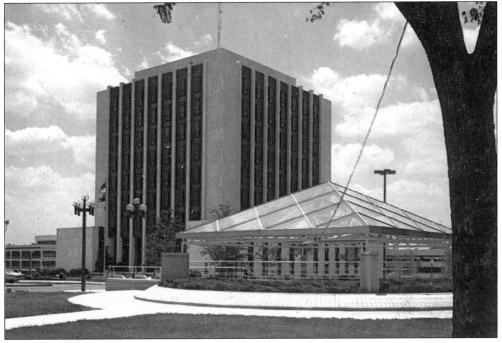

The current courthouse, DeKalb's sixth, was built in 1967 on the southwest corner of Courthouse Square. In the foreground is an entrance to the Decatur Station of the Metro Atlanta Rapid Transit Authority, built in 1977.

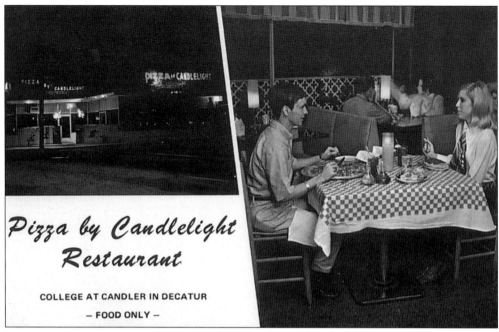

Pizza by Candlelight
Restaurant

COLLEGE AT CANDLER IN DECATUR

— FOOD ONLY —

A popular Decatur eating establishment, Pizza by Candlelight is fondly remembered by Agnes Scott College alumnae of the 1960s and 1970s and is mentioned in many student publications of the era. Though currently vacant, the "P by C" building still remains on the corner of College Avenue and Candler Street.

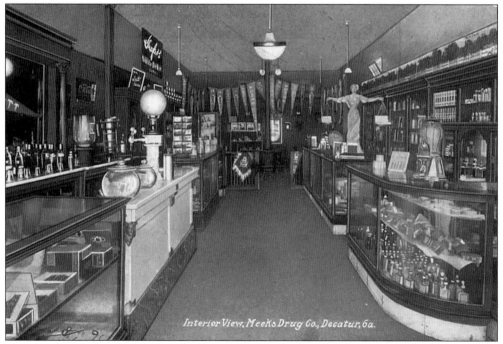

An artistic depiction of the interior of Meeks Drug Co. in Decatur reveals various toiletry items interspersed with Agnes Scott College pennants.

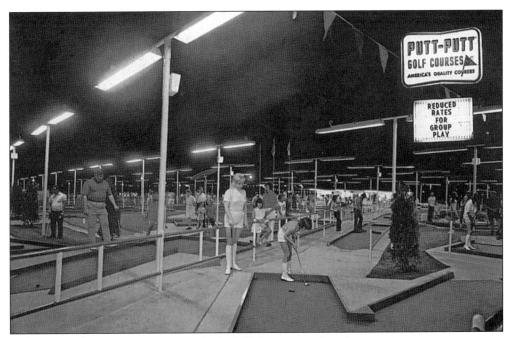

In the 1970s, this putt-putt course on Buford Highway was a favorite attraction.

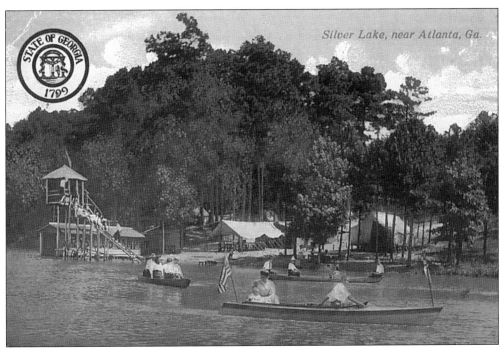

Boating on Silver Lake on a sunny summer day was another much-loved activity. Silver Lake is located in Brookhaven near the present-day Lenox Square and Phipps Plaza.

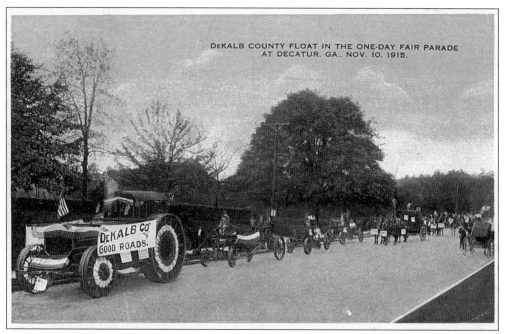

Parades such as the One-Day Fair Parade of November 10, 1915, seen here, drew large crowds and many floats, including this one advertising DeKalb County's "good roads."

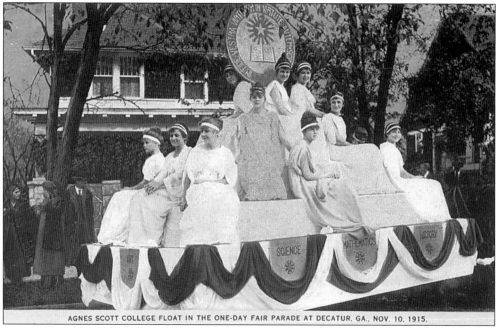

AGNES SCOTT COLLEGE FLOAT IN THE ONE-DAY FAIR PARADE AT DECATUR. GA.. NOV. 10. 1915.

Agnes Scott College also participated in the One-Day Fair Parade, entering a float that extolled the virtues of science, mathematics, history, and art education for women, while reassuring the community that an educated woman retained her grace and femininity.

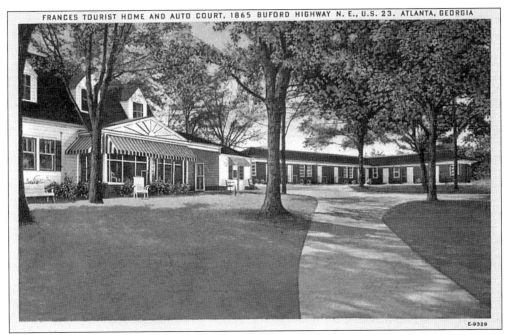

The Frances Tourist Home and Auto Court was located on Buford Highway and was advertised as the "closest auto court to downtown Atlanta." The Frances boasted 40 "modern" guest rooms, each with a private bath, as well as hot water and air conditioning.

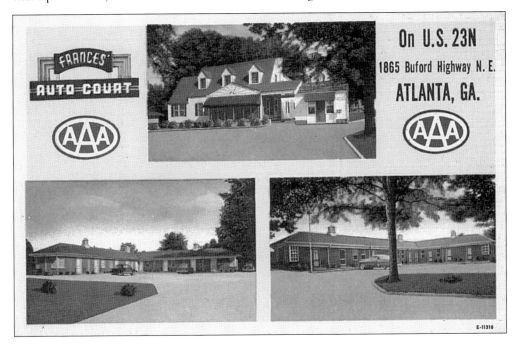

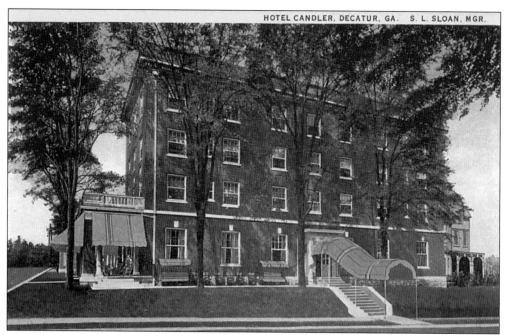

The Hotel Candler, located at the corner of Ponce de Leon Avenue and Church Street, was advertised as "fireproof" and "European-style."

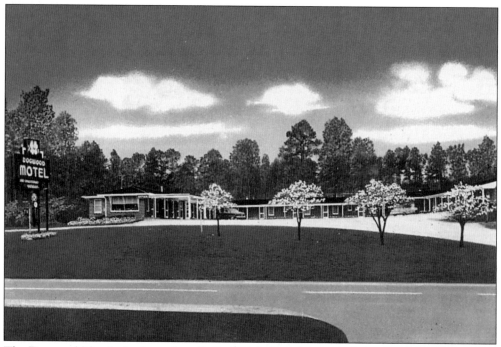

The Dogwood Motel, also located on Buford Highway, advertised all the "modern" amenities of the Frances Tourist Home and Auto Court, as well as "Beauty-rest" beds and in-room televisions and telephone service.

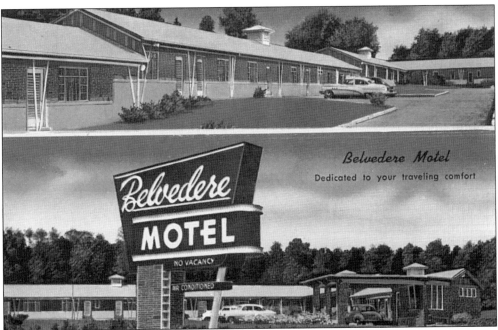

The Belvedere Motel, located on Memorial Drive near Stone Mountain, boasted steam heating, air-conditioning, in-room telephones, "large-screen" televisions, and king-size beds, as well as a playground, shuffleboard court, and swimming pool. Under the management of H.J. Beecham, the Belvedere bragged of a neighboring 18-hold golf course. As a "Dinkler Motor Inn" (below), the complex included an ice-skating rink.

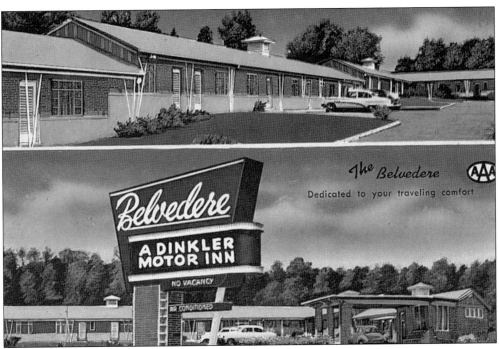

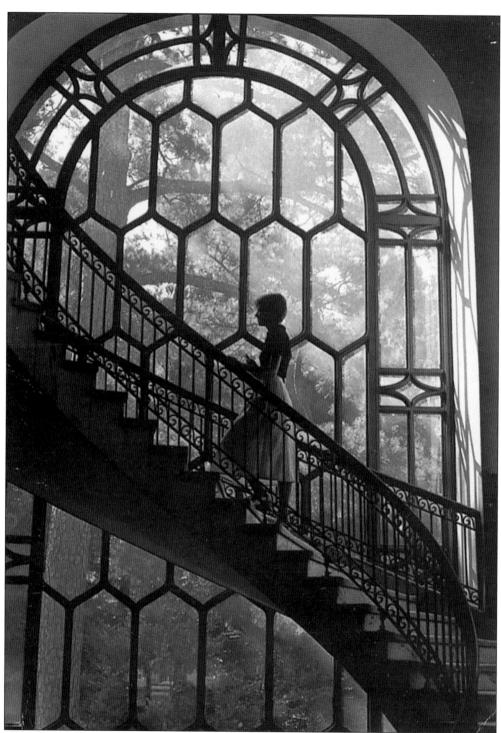

This pink marble staircase rises gracefully from the first floor of Emory University's Carlos Hall. The Italian Renaissance staircase and the window behind it comprise a striking addition to the quadrangle building that is home to the art history department, among others.

Two
CHURCHES

As in other counties throughout the South, the people of DeKalb have built many churches, and several congregations have used postcards to commemorate their respective histories. The oldest church in DeKalb is Macedonia Primitive Baptist, organized in 1822. The church and cemetery are located in the southern part of the county. With the county site's formation in 1823 came Decatur Presbyterian, and Decatur First Methodist followed in 1825.

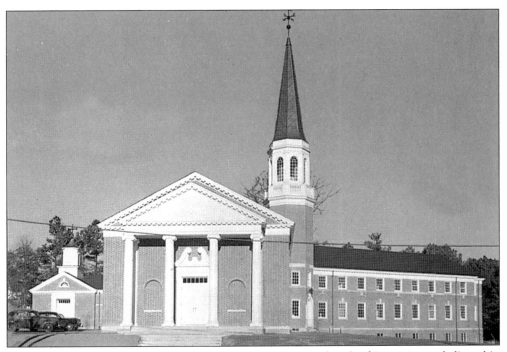

Located on West Ponce de Leon Avenue, the First Christian Church of Decatur was dedicated in November of 1950.

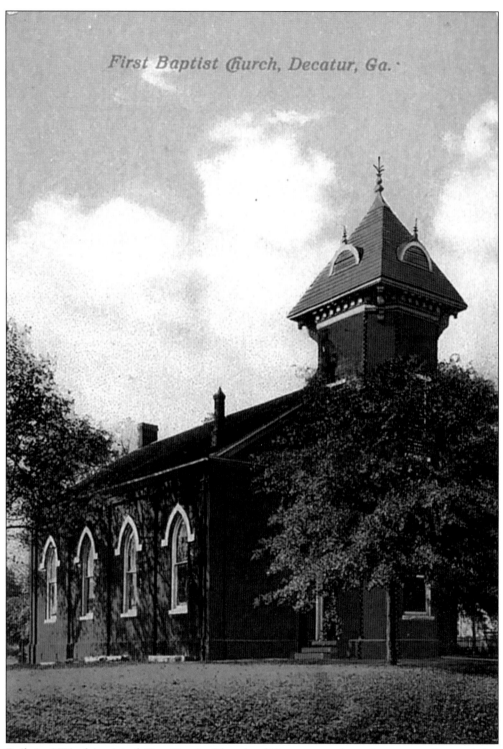

First Baptist Church, Decatur, Ga.

Built in 1871, the original First Baptist Church of Decatur stood on the corner of present-day Church Street and Trinity Place.

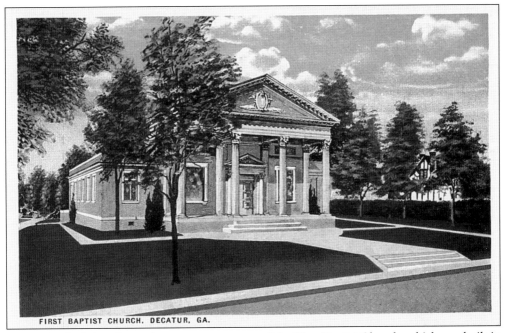

FIRST BAPTIST CHURCH, DECATUR, GA.

An artistic depiction shows the current sanctuary of the First Baptist Church, which was built in 1951. Sunday school classes were held in the white building at the far right.

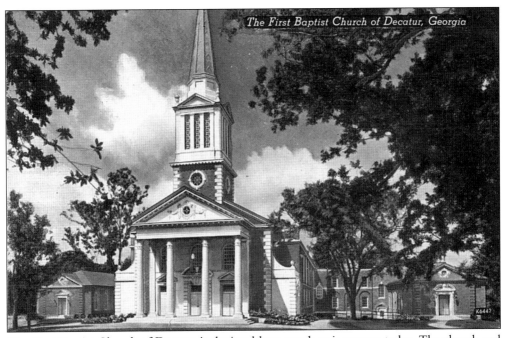

The First Baptist Church of Decatur, Georgia

The First Baptist Church of Decatur is depicted here much as it appears today. The church and grounds encompass more than 11 acres at the corner of Commerce Drive and Clairemont.

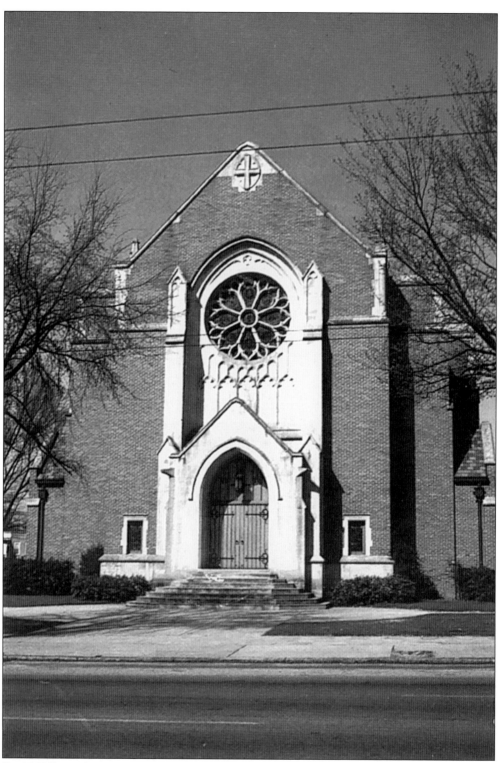

Druid Hills Presbyterian Church is located on Ponce de Leon Avenue.

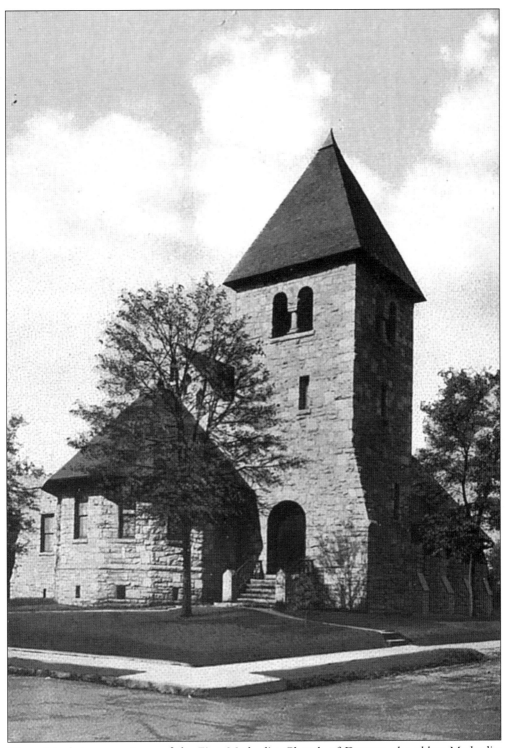

The original stone sanctuary of the First Methodist Church of Decatur, the oldest Methodist Church in Atlanta, was built in 1825.

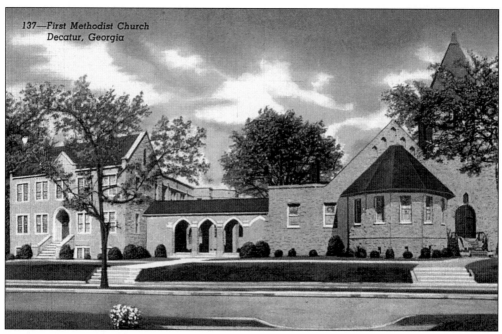

137—First Methodist Church
Decatur, Georgia

The original First Methodist Church buildings faced Sycamore Street.

The modern Georgian sanctuary of the Decatur First United Methodist Church has a seating capacity of 1,100.

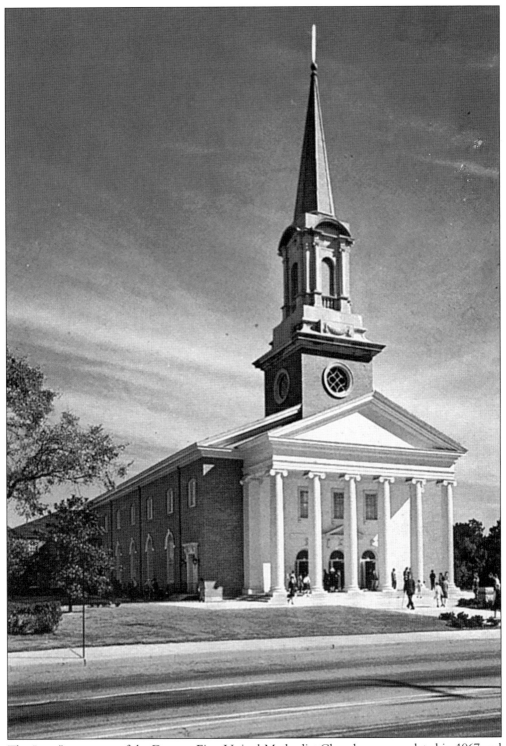

The "new" sanctuary of the Decatur First United Methodist Church was completed in 1967 and faces Ponce de Leon Avenue.

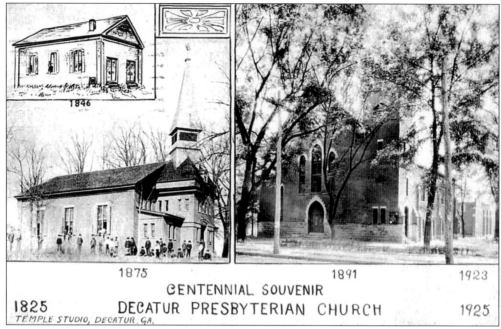

A commemorative postcard issued for the centennial of Decatur Presbyterian Church in 1925 depicts the various styles of the church over the previous century. Shown are the sanctuaries built in 1846, 1875, and 1891.

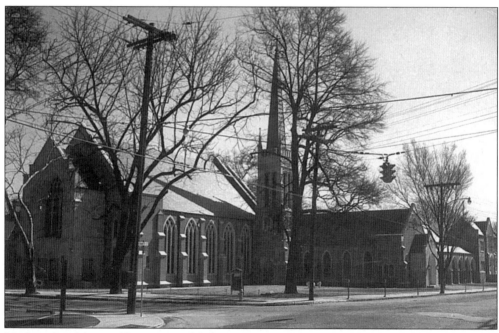

Modern-day visitors to Decatur can visit the current Decatur Presbyterian Church building, which stands on the corner of Sycamore and Church Streets.

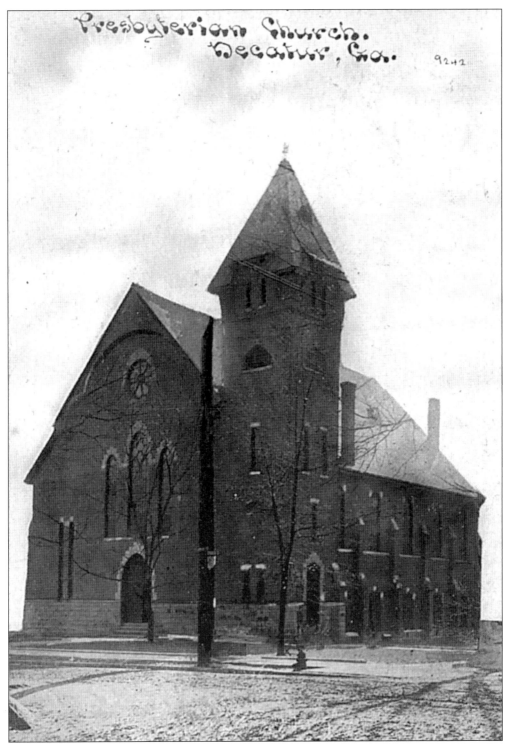

Decatur Presbyterian Church has enjoyed a long relationship with nearby Agnes Scott College, which was founded in 1889. This sanctuary was built in 1891.

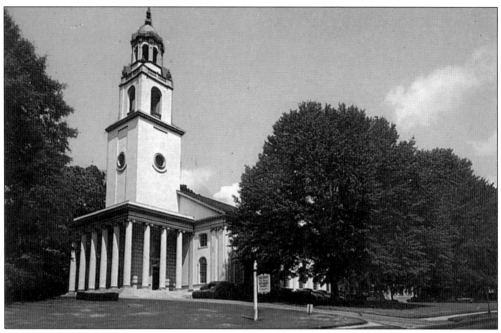

Standing just inside the front gates of Emory University, Glenn Memorial United Methodist Church serves both as a community church and as the university chapel.

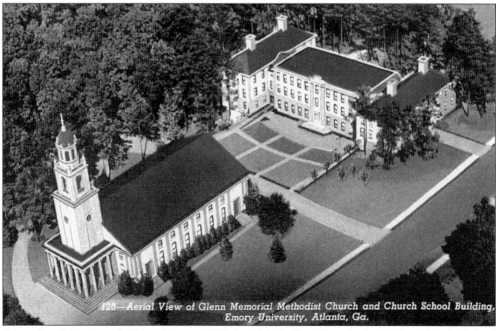

120—Aerial View of Glenn Memorial Methodist Church and Church School Building, Emory University, Atlanta, Ga.

An earlier depiction of Glenn Memorial United Methodist Church shows the Church School Building (presently used as classrooms by Emory University) and the amphitheater where commencement exercises were held for a number of years.

Three

EDUCATION

DeKalb County is home to many educational institutions. From the public elementary and high schools of the area to places of higher learning, such as Emory and Oglethorpe Universities, Columbia Seminary, and Agnes Scott College, DeKalb has always been a place of lifelong learning. Among the institutions of higher learning in DeKalb, only Agnes Scott College and DeKalb College were founded here; the others moved from prior locations to DeKalb County or are affiliates of schools in other areas of the state.

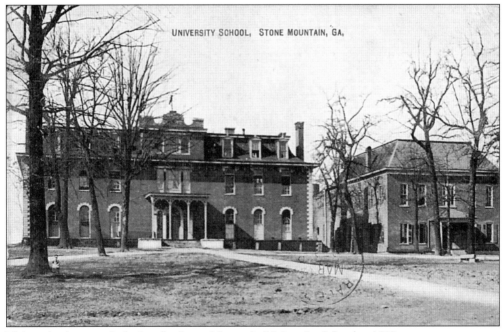

This early photograph depicts the Stone Mountain University School, *c.* 1910.

Originally facing present-day College Avenue, the Candler Memorial Gates now mark the Candler

Street pedestrian entrance to the Woodruff Quadrangle between Winship and Walters Halls.

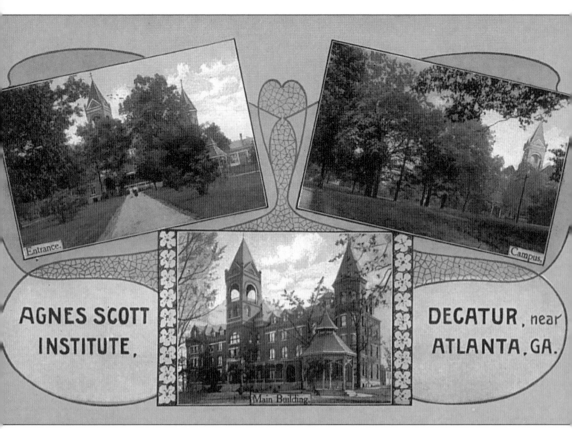

Following a substantial endowment by Col. George Washington Scott in honor of his mother, Agnes, the Decatur Female Seminary was christened the Agnes Scott Institute in 1889.

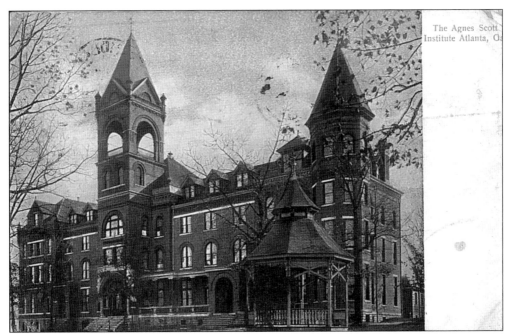

Built in 1891, Agnes Scott Hall (known as "Main") is the oldest building on the Agnes Scott College campus and was home to the Agnes Scott Institute until 1906, when the school became Agnes Scott College.

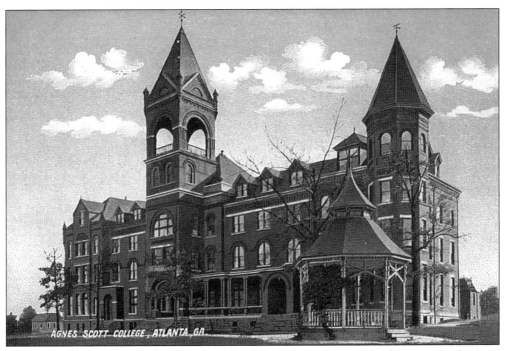

The Agnes Scott Institute, a Presbyterian school for women, became the first accredited private college in Georgia in 1906.

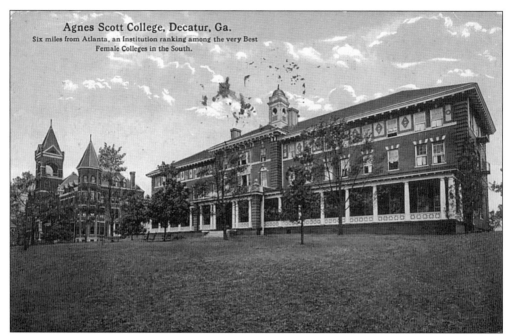

The dedication of Rebekah Scott Hall, the second school building on the Agnes Scott College campus, coincided with the 1906 commencement exercises.

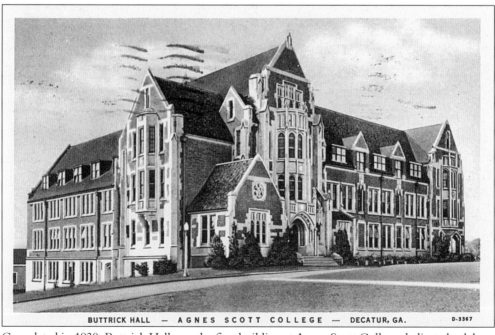

BUTTRICK HALL — AGNES SCOTT COLLEGE — DECATUR, GA. D-3367

Completed in 1930, Buttrick Hall was the first building at Agnes Scott College dedicated solely to administration and academics.

36

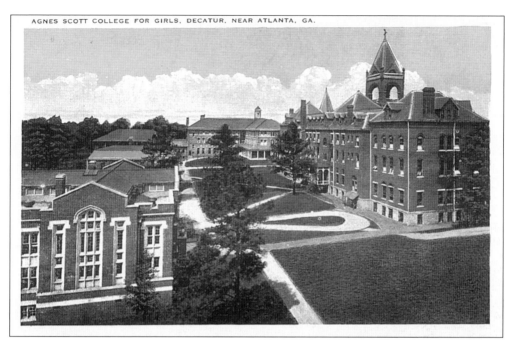

An artistic depiction of the central campus shows the rear of Agnes and Rebekah Scott Halls on the right and Bucher Scott Gymnasium in the left foreground.

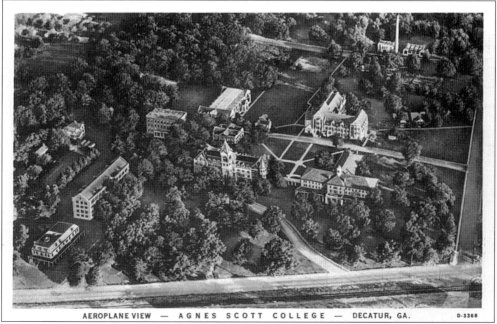

An aerial view of Agnes Scott College shows (clockwise from bottom left) an unidentified structure, Inman Hall, Bucher Scott gymnasium, Buttrick Hall, and the two original buildings, now used as dormitories. The Hub, center of student activities until the 1980s, stands on the quadrangle between Main and the gymnasium.

37

Demolished in 1999, the Agnes Scott College dining hall was rebuilt in the same Gothic style in 2000 and named for Letitia Pate Evans.

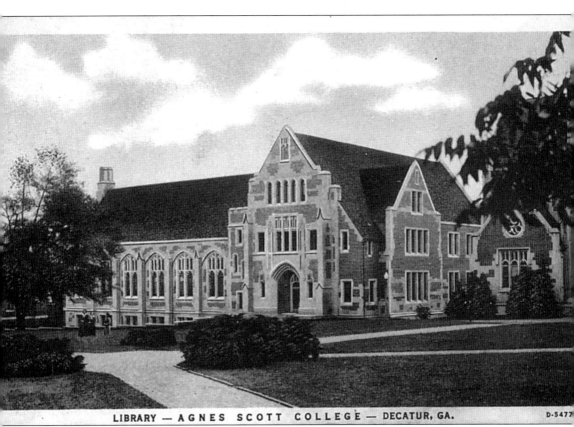

LIBRARY — A G N E S S C O T T C O L L E G E — DECATUR, GA.

D-5477

Endowed by the Carnegie Corporation in 1935, the Agnes Scott College Library was renamed for president James Ross McCain in 1951.

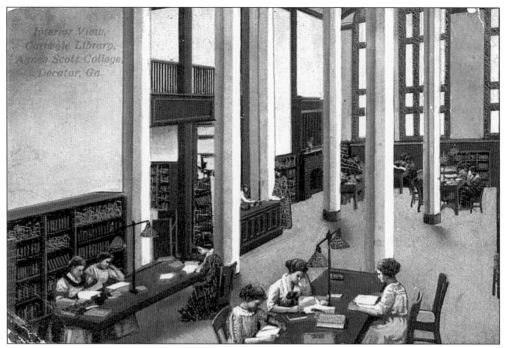

An early interior view of the Carnegie Library at Agnes Scott College shows students hard at work in the 1930s.

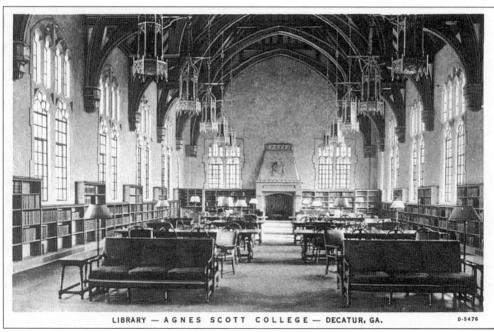

LIBRARY — AGNES SCOTT COLLEGE — DECATUR, GA. D-5476

Even after renovations were completed in January of 2001, the interior reading room of the McCain Library remains similar in appearance to that shown here.

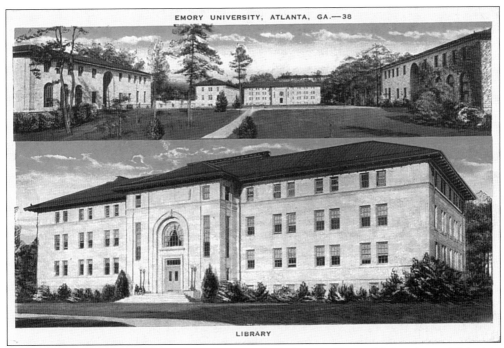

LIBRARY

Chartered by Southern Methodists in 1836 in Oxford, Georgia, Emory University established its Atlanta campus in 1915. The Candler Library is located on the main quadrangle.

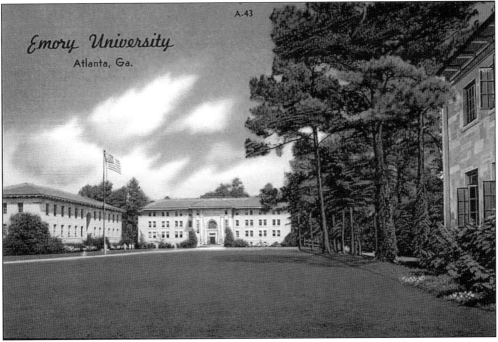

Candler Library is shown flanked by the Callaway Center on the left and Carlos Hall on the right. Four more buildings were later erected to create the present-day quadrangle of the Emory University campus.

41

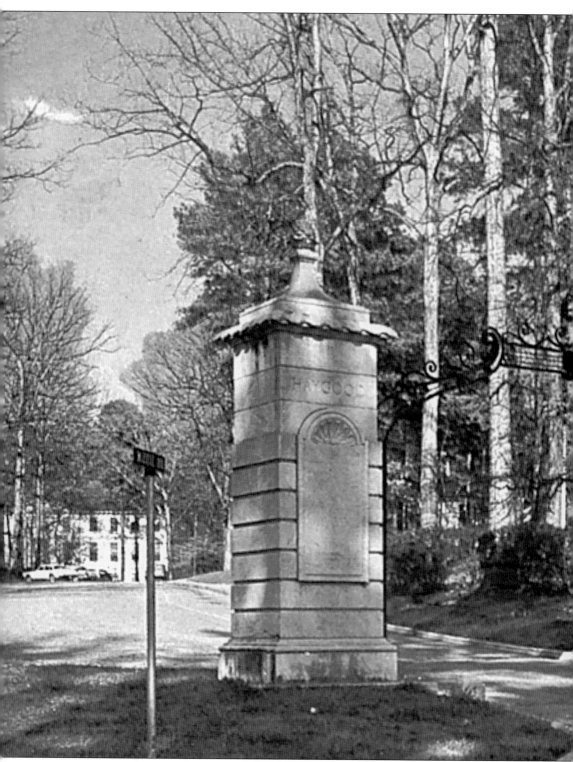

This chain gate marks the front entrance to Emory University. Through the trees behind the gate

stands Glenn Memorial United Methodist Church.

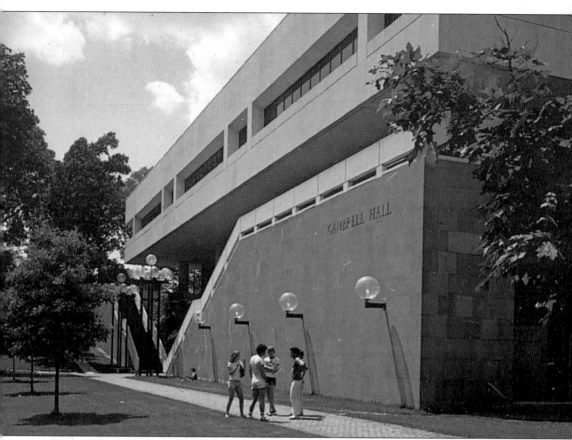

Gambrell Hall, located on the corner of Clifton and North Decatur Roads, houses the Law Library and other departments of Emory University Law School.

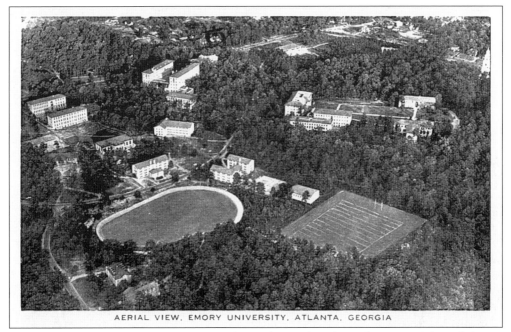

AERIAL VIEW, EMORY UNIVERSITY, ATLANTA, GEORGIA

An early aerial view of Emory University shows the quadrangle in the upper right and Emory University Hospital in the upper left.

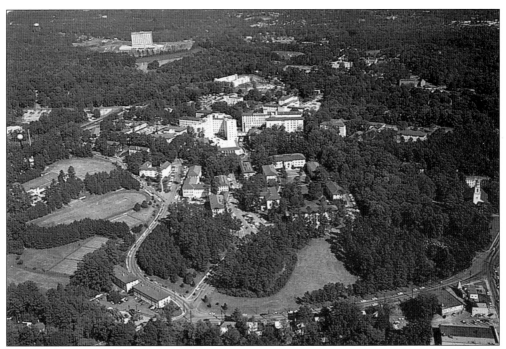

A modern aerial view of Emory University shows the terra cotta roofs and marble buildings of the spacious campus and hospital complexes.

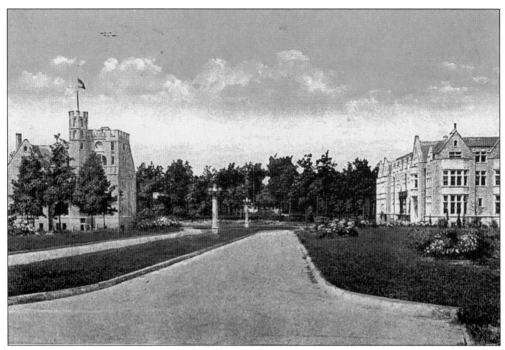

Having closed its Atlanta campus during the Civil War, Oglethorpe University moved to DeKalb County in 1912 and reopened for classes in September of 1916. Shown above is the main entrance to the campus.

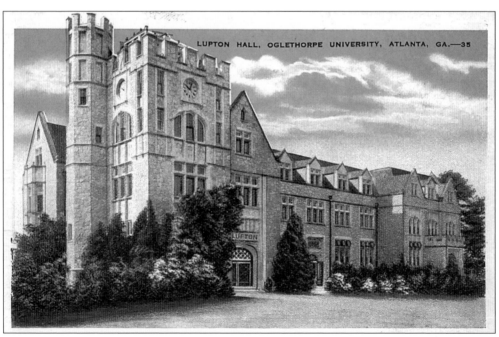

Lupton Hall, one of three original buildings on the Oglethorpe University campus, has housed a variety of facilities, including athletics, the library, and the office of the university president.

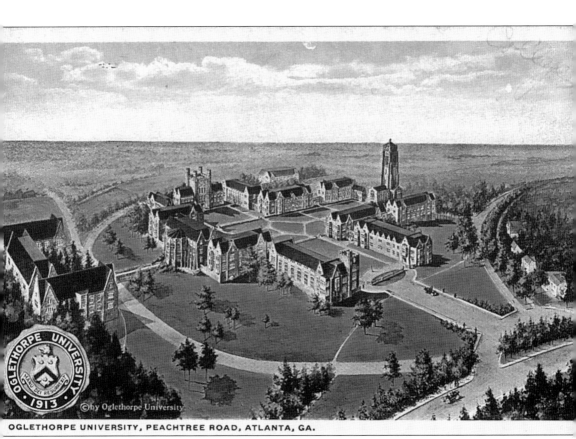

OGLETHORPE UNIVERSITY, PEACHTREE ROAD, ATLANTA, GA.

An aerial depiction shows the close-knit campus of Oglethorpe University. Also shown is the College seal, with its motto "Manu Dei Resurrexit," which alludes to its restoration following the Civil War.

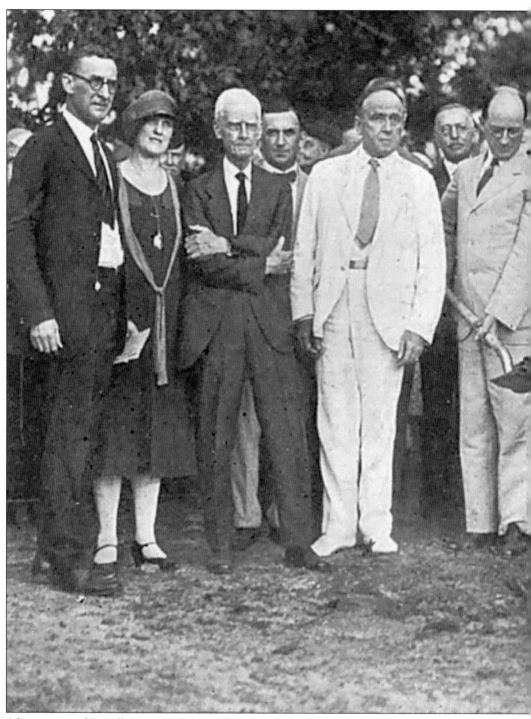

A large group of DeKalb County citizens gathered to participate in a groundbreaking ceremony for Columbia Theological Seminary, held on September 13, 1926. The entering class was, at that time,

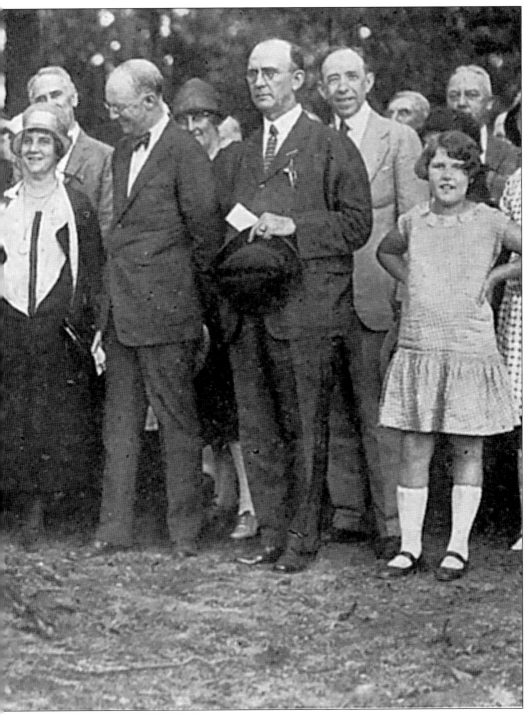

the largest in the Seminary's 98-year existence.

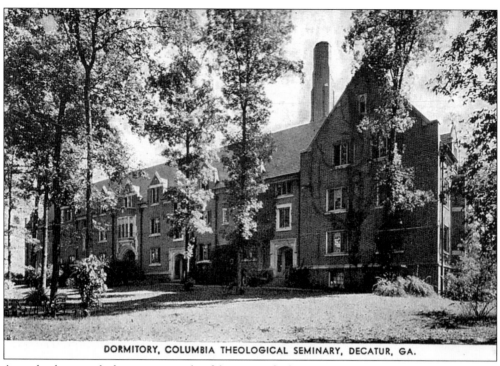

DORMITORY, COLUMBIA THEOLOGICAL SEMINARY, DECATUR, GA.

An early photograph shows an example of dormitory facilities at Columbia Theological Seminary.

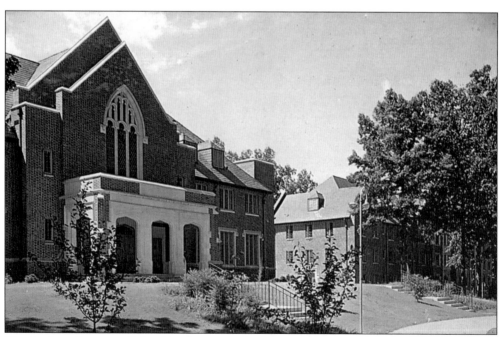

The Student Center at Columbia, shown on the left, included a dining hall, recreation rooms, classrooms, and the bookstore. Married students were housed in Florida Hall, a dormitory with a 126-person occupancy located next to the Student Center.

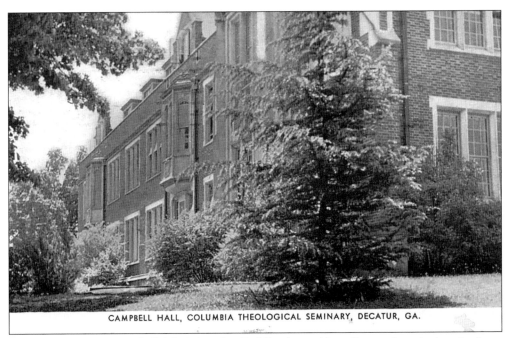

CAMPBELL HALL, COLUMBIA THEOLOGICAL SEMINARY, DECATUR, GA.

The Virginia Orme Campbell Administration Building housed boarding students in dormitories as well as administrative and faculty offices.

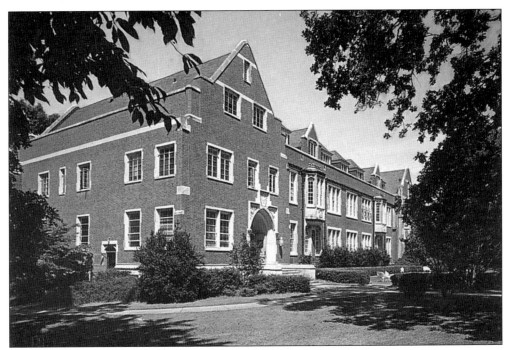

Campbell Hall was also built to house classrooms, and a chapel was constructed in the north wing of the building.

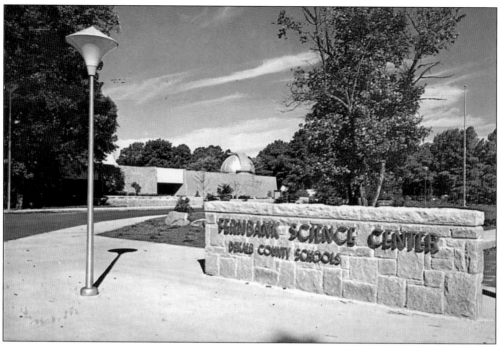

The Fernbank Science Center contains a planetarium and observatory as well as science exhibit areas. Fernbank Forest was purchased in 1937 from Col. Z.D. Harrison, and in 1964, under the leadership of DeKalb Superintendent of Schools Jim Cherry, Fernbank Science Center was constructed on the edge of the 65-acre primeval forest.

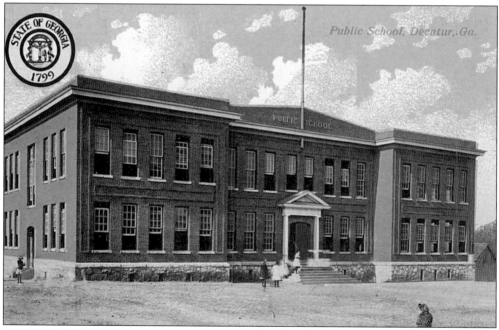

An artistic depiction illustrates the public school in Decatur that most closely resembles Glenwood Elementary, that city's oldest school.

Four

NEIGHBORHOODS

Though the neighborhoods of DeKalb County's many communities have changed greatly over the years, many of the homes featured on these postcards grace the same streets today as in days gone by. Historic Druid Hills was a planned development surrounding Emory University and featured large homes built on sloping yards and curving streets. Avondale Estates, created in 1925, was the vision of George Willis, who modeled the development's architecture on Stratford, England.

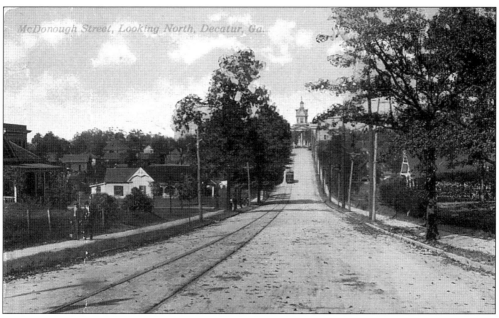

Many years ago, one could head north from the intersection of College Avenue and McDonough Street and follow the streetcar rails all the way to the DeKalb County Courthouse on Ponce de Leon Avenue in Decatur.

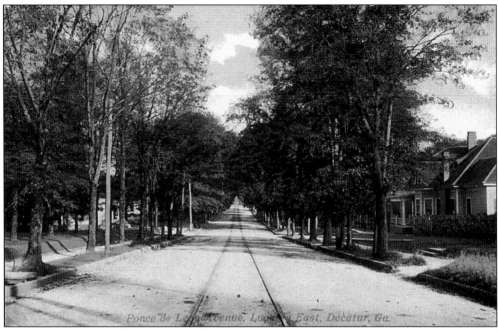

Streetcar rails run straight down the middle of Ponce de Leon Avenue in this depiction, which shows the residences lining Ponce de Leon as one travels east from downtown Decatur.

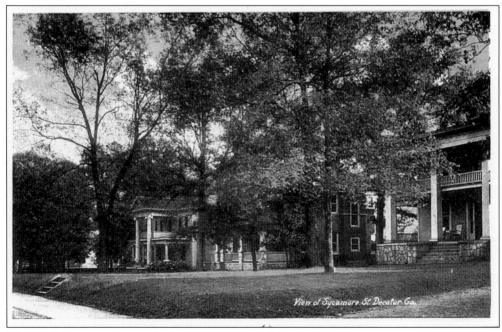

The fall foliage emphasizes the beauty and grace of these antebellum mansions along Sycamore Street, which formed the south side of the Courthouse Square and parallels Ponce de Leon Avenue east of downtown Decatur.

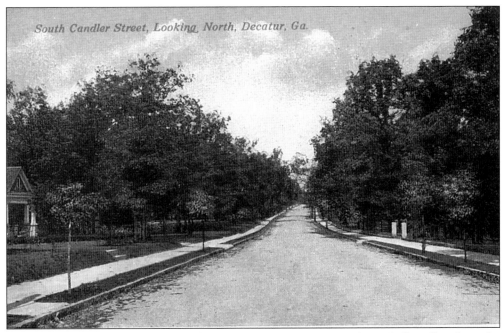

Homes and gardens line South Candler Street in Decatur. Agnes Scott College lies along the northern section of South Candler Street beyond the horizon.

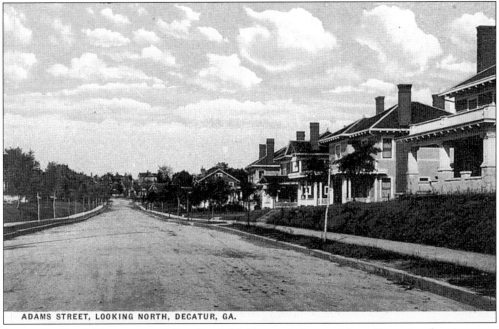

ADAMS STREET, LOOKING NORTH, DECATUR, GA.

Located in South Decatur paralleling South McDonough Street, Adams Street is a favorite route for joggers and other pedestrians who enjoy the beautiful homes and shady streets. Leila Ross Wilburn, an Agnes Scott graduate, designed many of the homes built around 1910.

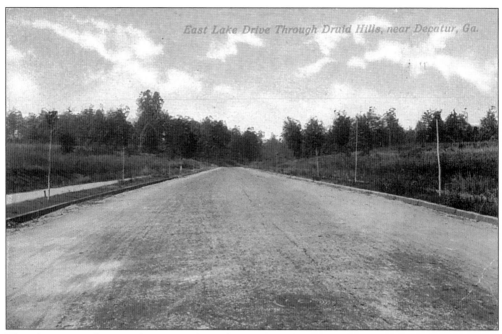

This depiction of East Lake Drive through Druid Hills shows the pastures and landscape of earlier times.

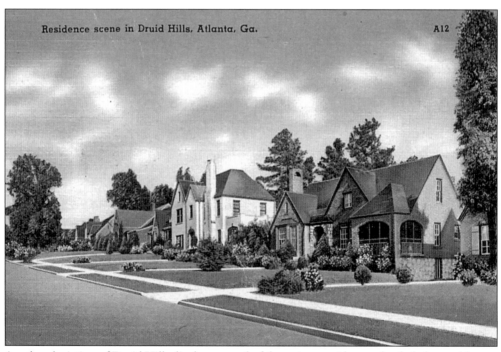

Another depiction of Druid Hills displays several of the unique residences that help keep addresses in this historic area in great demand.

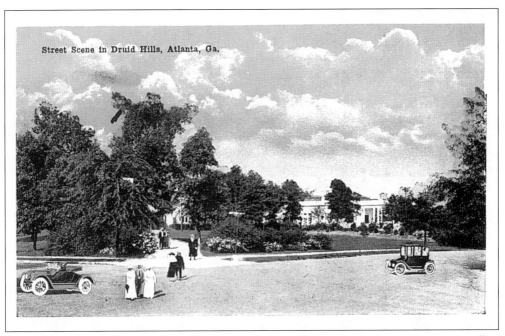

An early "street scene" from Druid Hills shows the Candler residence in the distance as well as lush, green trees and immaculate gardens.

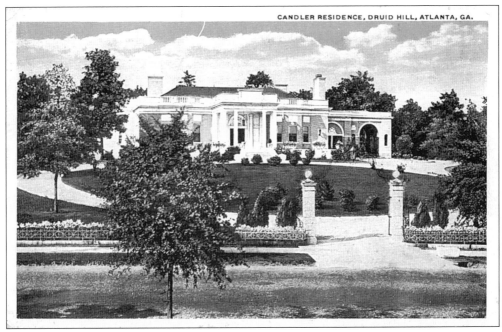

Located in Druid Hills, the Candler residence was home to Asa Griggs Candler, the founder of Coca-Cola.

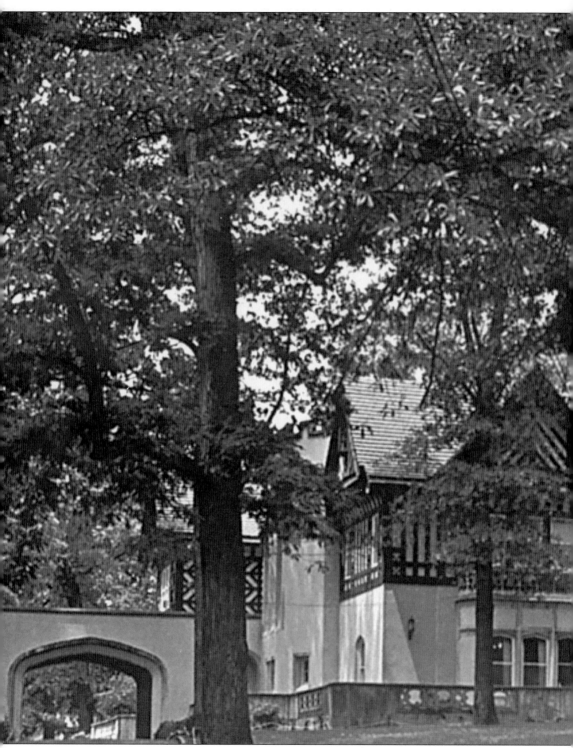

Callanwolde, located on Briarcliff Road, was the home of Charles Howard Candler, the son of Asa Griggs Candler. Now listed in the National Register of Historic Places, the estate is currently

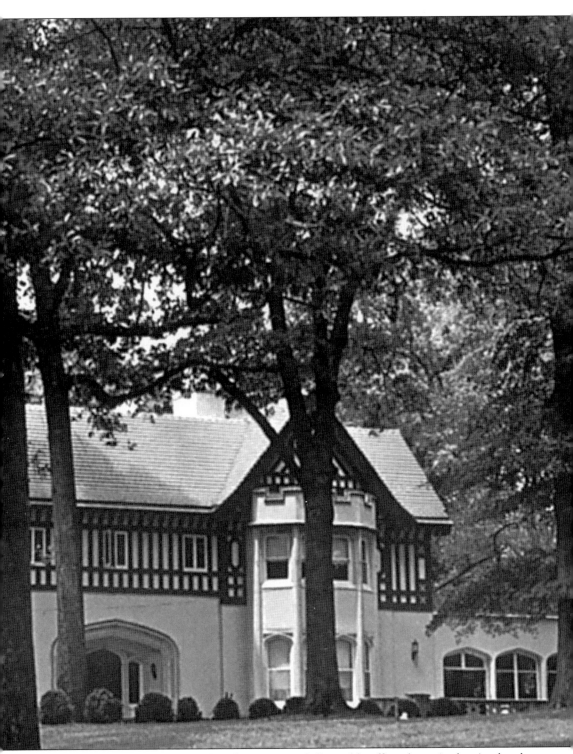

owned by DeKalb County. As a cultural arts center, Callanwolde offers classes in the visual and performing arts.

Scene Near
CLARKSTON, GA.

We're looking for you every day
And so we send this line
To say, please hurry up and come
For the water here is fine.

This postcard and the one on the opposite page offer witty verses along with views of the landscape near Clarkston, a DeKalb County community northeast of Decatur.

Scene Near
CLARKSTON, GA.

 There is so much good in the worst of us,
There is so much bad in the best of us.
That it ill behooves any of us,
To talk about the rest of us.

Clarkston, originally known as "goat town" is one of the DeKalb municipalities that formed along the railroad.

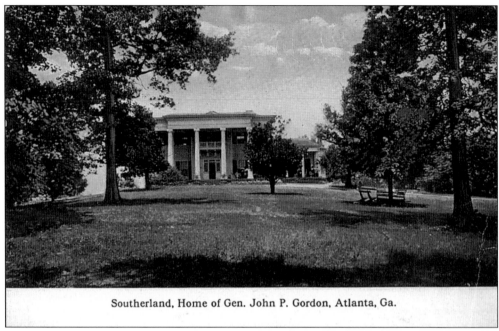

Southerland, Home of Gen. John P. Gordon, Atlanta, Ga.

Sutherland was built in 1899 to replace the home that burned on the same site. The estate was the home of John Brown Gordon, who was a senator and Confederate general as well as the governor of Georgia from 1886 to 1890.

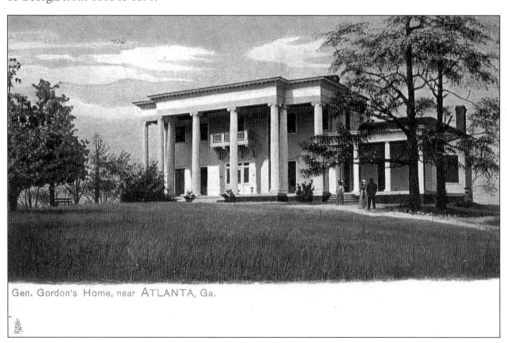

Gen. Gordon's Home, near ATLANTA, Ga.

Five

GIANT ROCK

Once a landmark for the Native Americans living in its shadow, Stone Mountain is the largest piece of exposed granite in the world and has long been a popular tourist destination for visitors to the South. Known first as New Gibraltar, the village originally sat at the base of the mountain. It was renamed and relocated after 1845 when the railroad came through. The mountain itself has remained popular for both residents and tourists. One early tourist site was "Cloud's Folly," a wooden tower built atop the mountain. For 5¢ a climb to the top afforded a spectacular view.

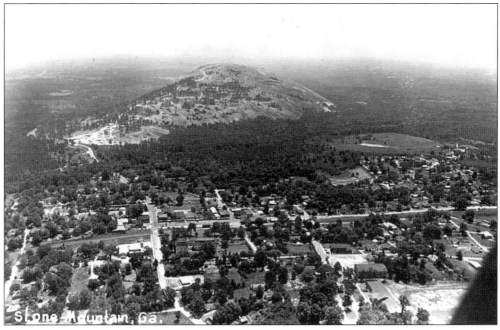

Stone Mountain rises over the village below in this photograph taken in the 1940s. While the village has changed greatly over the years, one constant remains: Stone Mountain still towers over the community that shares its name.

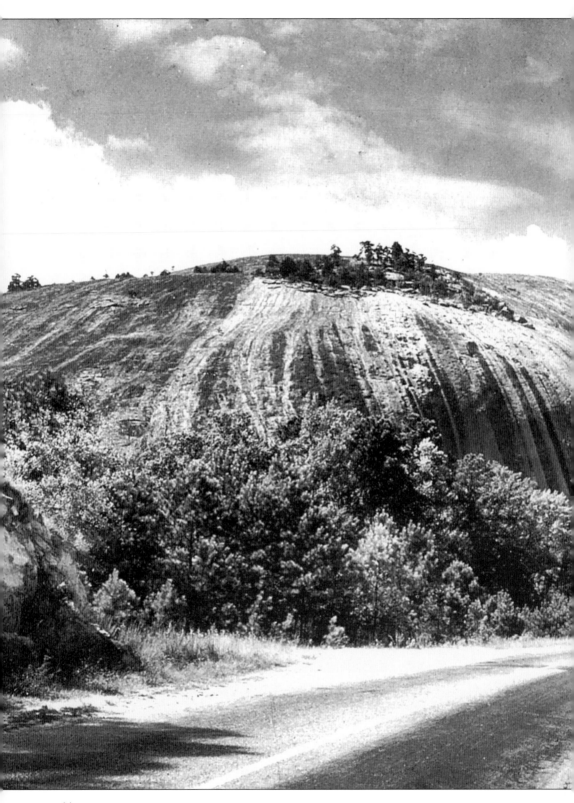

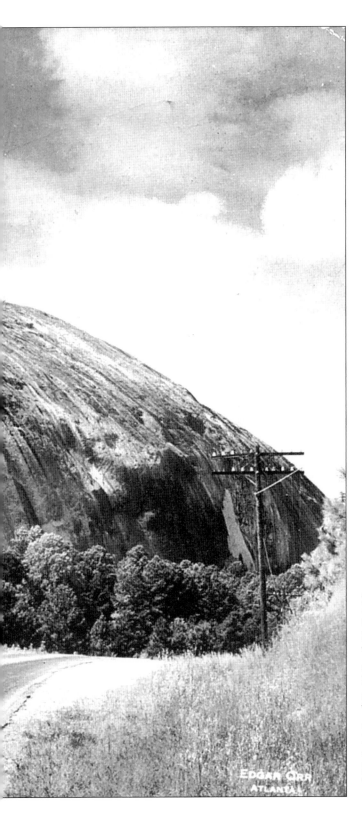

EDGAR ORR
ATLANTA

An oversized postcard from the DeKalb Chamber of Commerce depicts the natural beauty of Stone Mountain. With 4 million visitors annually, this "giant rock" has become the South's second most popular tourist attraction. Year after year, visitors from all over the country visit Stone Mountain to see for themselves the formation that has been called the "Eighth Wonder of the World."

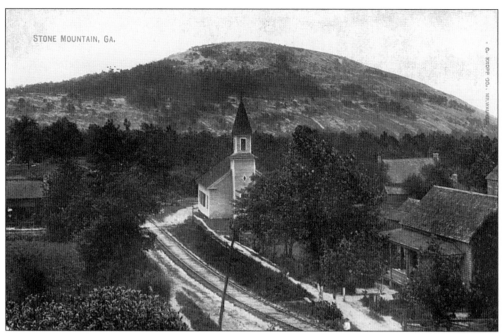

STONE MOUNTAIN, GA.

A view of the village of Stone Mountain as it appeared around the turn of the century shows the wood frame houses and church as well as the railroad tracks running through the middle of the community.

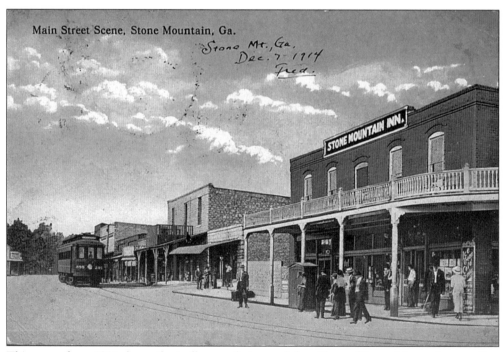

Main Street Scene, Stone Mountain, Ga.

Stone Mt., Ga.
Dec. 7-1914
Fred.

STONE MOUNTAIN INN.

This scene from 1914 shows the trolley car that served the village of Stone Mountain as well as several Main Street establishments. The village was also accessible by train and automobile.

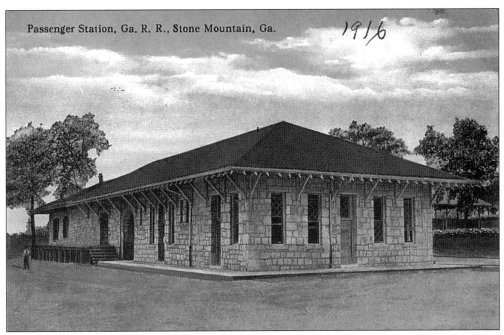

The Georgia Railroad brought passengers and freight to the Stone Mountain depot, shown here as it appeared in 1916.

Shown here is a lively depiction of the "Big Shanty" show. During many a summer, "Indians" attacked the Scenic Railroad train at Big Shanty on each and every trip around the mountain.

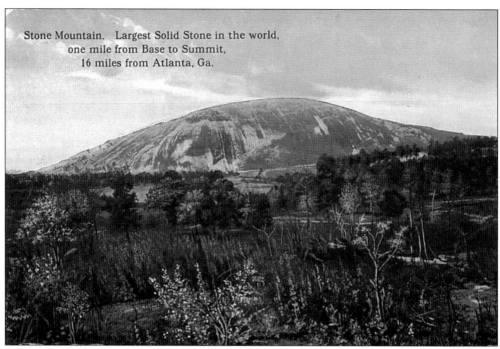

Stone Mountain. Largest Solid Stone in the world,
one mile from Base to Summit,
16 miles from Atlanta, Ga.

Many postcards of the time touted the impressive size of Stone Mountain—and rightfully so, as the enormous rock measured seven miles in circumference at its base and was made of over 16 billion cubic feet of exposed granite. However, despite the lofty claims of this postcard, the mountain rose only a mere 1,683 feet above the town below.

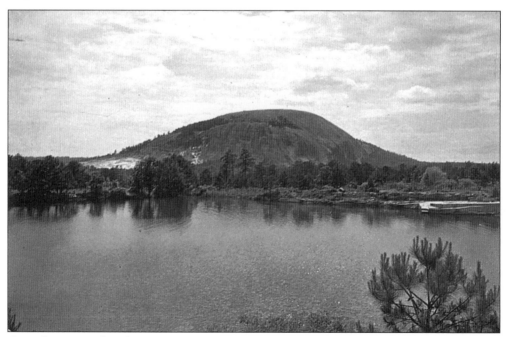

On a clear sunny day, the mountain and the lake below create a pleasant setting for a picnic, or a sail, or a beautiful photograph.

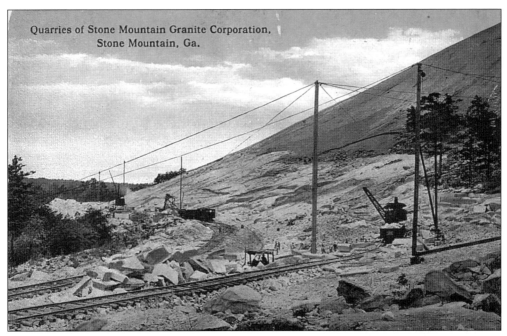

Quarries of Stone Mountain Granite Corporation,
Stone Mountain, Ga.

In the early part of the 20th century, the Stone Mountain Granite Corporation operated several quarries at the base of the mountain. These quarries provided granite that was used to build and pave growing cities all over America, including such places as Chicago and Cincinnati.

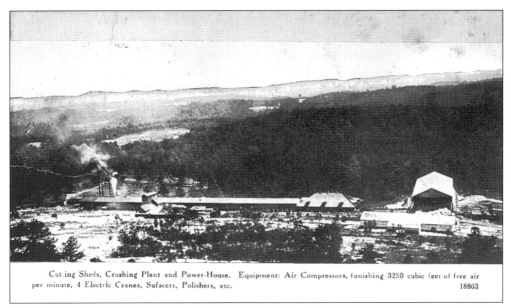

Cut.ing Sheds, Crushing Plant and Power-House. Equipment: Air Compressors, funishing 3250 cubic feet of free air per minute, 4 Electric Cranes, Sufacers, Polishers, etc. 18863

An aerial view of the Stone Mountain Granite Corporation shows the cutting sheds, crushing plant, electric cranes, polishers, and other devices that were essential to the quarrying business.

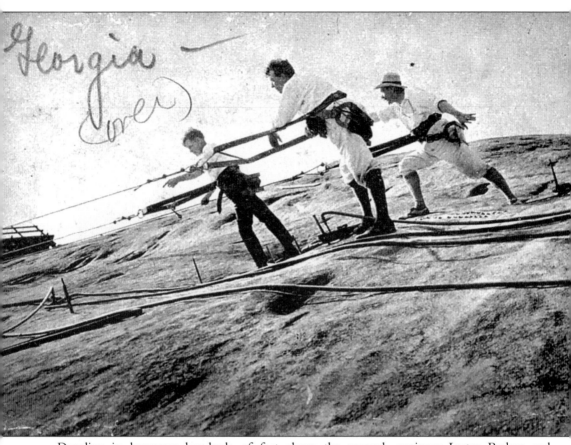

Dangling in harnesses hundreds of feet above the ground, engineer Lester Barlow and superintendent J.G. Tucker confer with original sculptor Gutzon Borglum about the Confederate Memorial to be carved into the side of Stone Mountain.

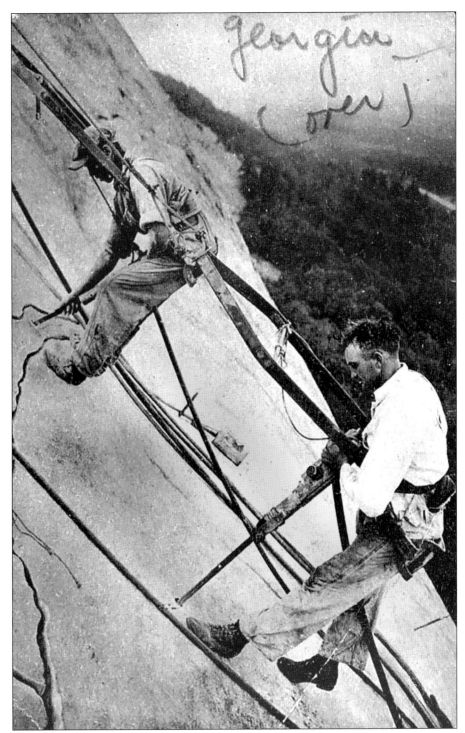

Workers in harnesses drill holes in the rock to remove slabs of granite from the site of the future Confederate Memorial. The area shown in this photo later formed the brim of Gen. Robert E. Lee's hat.

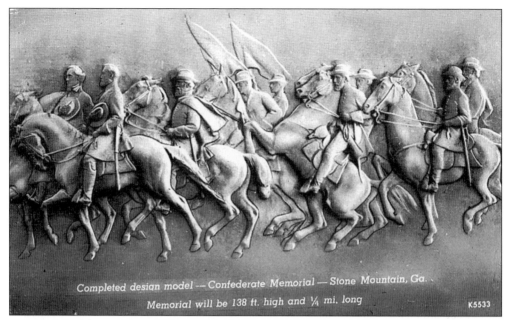

Completed design model — Confederate Memorial — Stone Mountain, Ga.
Memorial will be 138 ft. high and ¼ mi. long

K5533

A rendering of the proposed Confederate Memorial predicts the vast dimensions of the completed sculpture. The figures on the mountain were designed to be as tall as a 15-story office building.

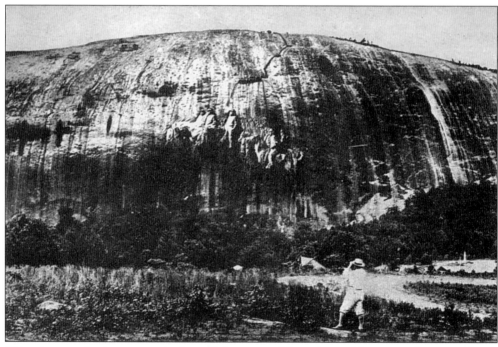

This photograph shows a projection of the memorial, as it would appear when completed. The original sculptor, Gutzon Borglum, is shown in the foreground, standing 1,500 feet from the mountain.

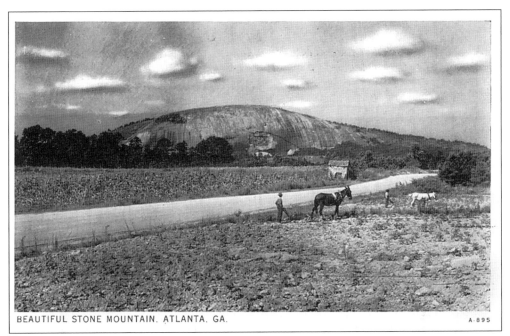

BEAUTIFUL STONE MOUNTAIN. ATLANTA. GA. A-895

These farmers have an excellent view of the ongoing sculpture construction from their fields several miles away.

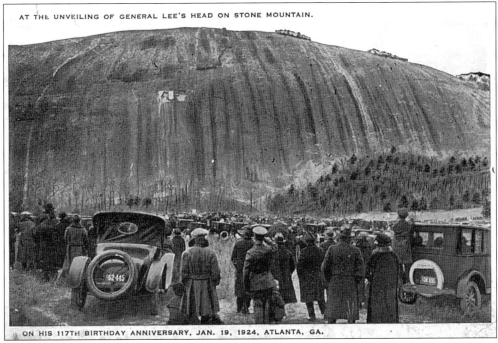

AT THE UNVEILING OF GENERAL LEE'S HEAD ON STONE MOUNTAIN.

ON HIS 117TH BIRTHDAY ANNIVERSARY, JAN. 19, 1924, ATLANTA, GA.

On January 19, 1924, the 117th anniversary of General Robert E. Lee's birth, thousands gathered to witness the unveiling of the first piece of the memorial—Borglum's version of General Lee's head.

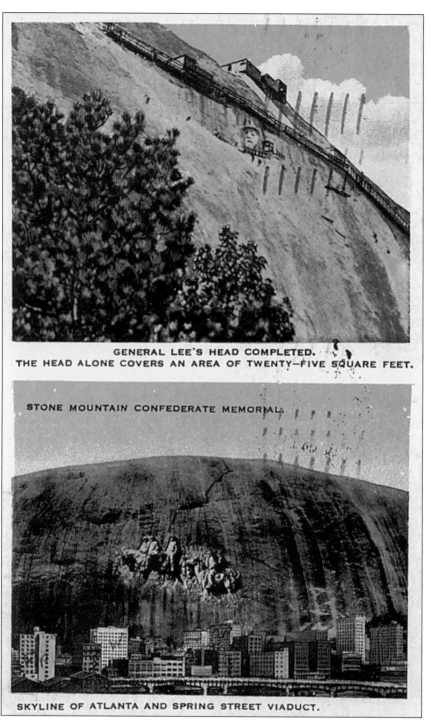

GENERAL LEE'S HEAD COMPLETED.
THE HEAD ALONE COVERS AN AREA OF TWENTY—FIVE SQUARE FEET.

STONE MOUNTAIN CONFEDERATE MEMORIAL.

SKYLINE OF ATLANTA AND SPRING STREET VIADUCT.

This commemorative card depicts the completed head of General Lee, which covered 25 square feet of the exposed granite. An amusing image is shown in the bottom half of the card, where the artist shows the mountain looming over the Atlanta skyline; in reality, Stone Mountain is located six miles from Atlanta and is not discernible against the city's skyline.

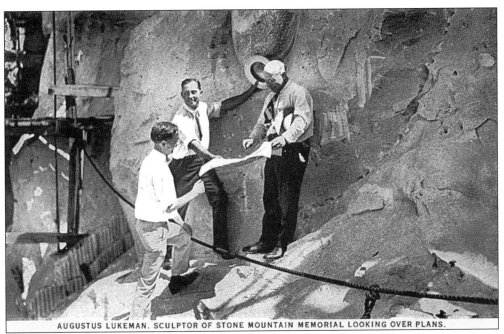

AUGUSTUS LUKEMAN, SCULPTOR OF STONE MOUNTAIN MEMORIAL LOOKING OVER PLANS.

In 1925, amid legal scandals, Gutzon Borglum abandoned the memorial carving. In 1928, Augustus Lukeman destroyed Borglum's work and began carving his version of the memorial from scratch. Here, Lukeman consults plans for the carving with his workers.

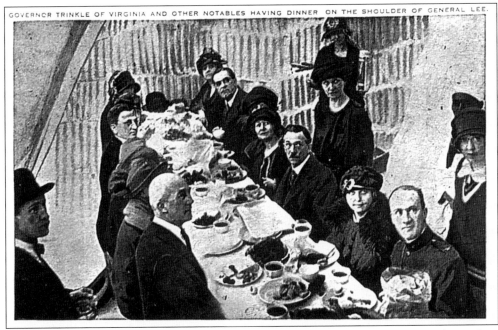

GOVERNOR TRINKLE OF VIRGINIA AND OTHER NOTABLES HAVING DINNER ON THE SHOULDER OF GENERAL LEE.

When the shoulder of the General Lee carving was revealed to the public, several members of Virginia society were invited to dine at a table placed on the shoulder itself. Governor Trinkle of Virginia and over a dozen guests enjoyed a meal on the sculpture, hundreds of feet above the ground.

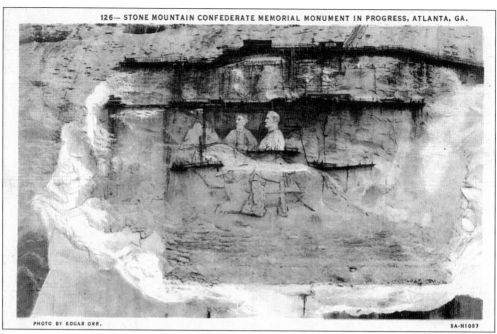

Here, the upper bodies of General Lee and Stonewall Jackson have been completed, along with the outlines of their horses. The completed figures were expected to be over 165 feet tall.

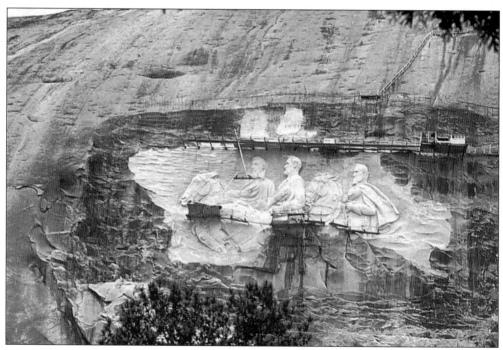

Next to be carved was the figure of Jefferson Davis, the president of the Confederacy. At this point, the carving covered nearly 60,000 square feet of the mountainside.

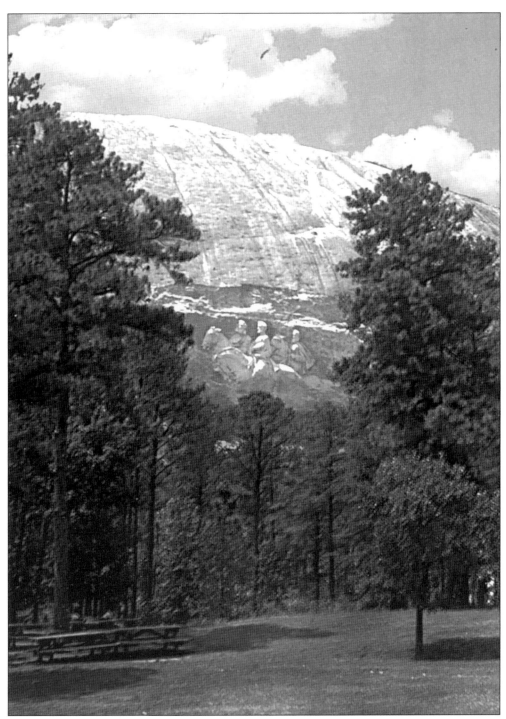

A photograph taken in recent years shows the memorial as seen by present-day visitors to Stone Mountain Park. After years of indecision, the Central Group was completed in 1970 under the direction of Walker Hancock. The figures of Robert E. Lee, Stonewall Jackson, and Jefferson Davis are all that resulted from the original grandiose plans for the Confederate monument.

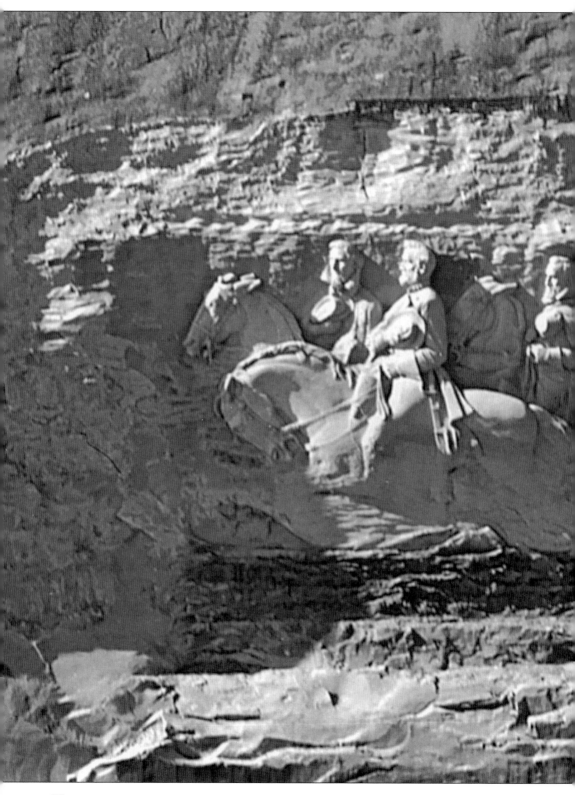

A recent postcard of the carving names the monument as the largest single memorial to the Confederacy. Indeed, many visitors to Stone Mountain journey to see the sculpture as well as other memorials to the Confederacy located in Stone Mountain Park.

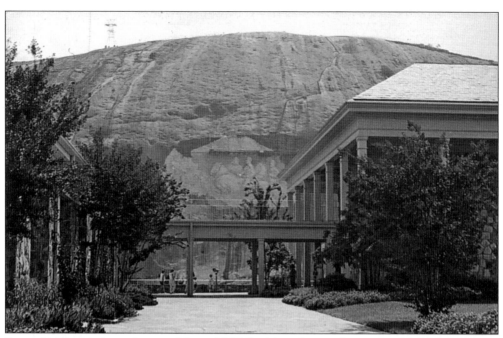

From this observation point near Memorial Hall, visitors have a clear view of the figures of Lee, Jackson, and Davis.

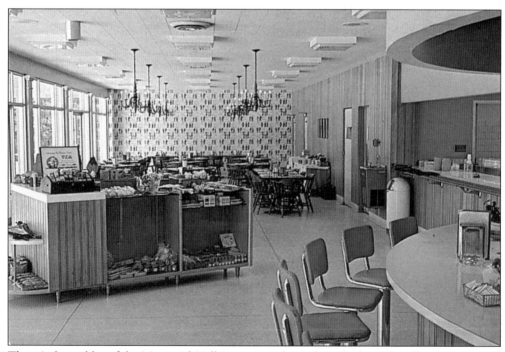

The window tables of the Memorial Hall Restaurant, located inside the Hall, offer a comfortable vantage point from which to observe the sculpture.

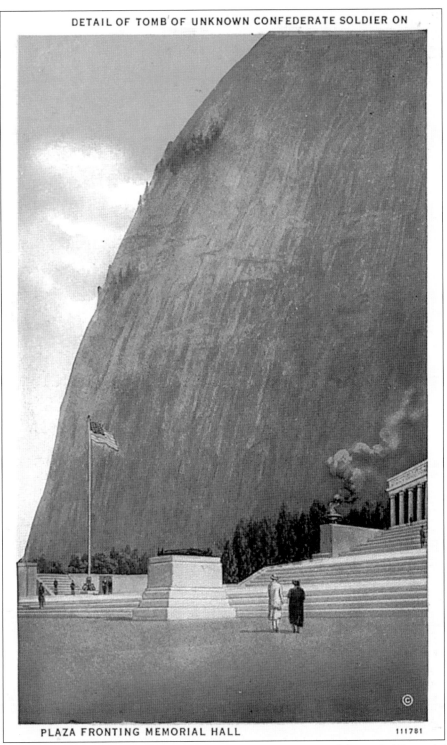

PLAZA FRONTING MEMORIAL HALL

111781

An artist created this drawing of the Tomb for the Unknown Confederate Soldier, originally planned for the Stone Mountain memorial but never completed.

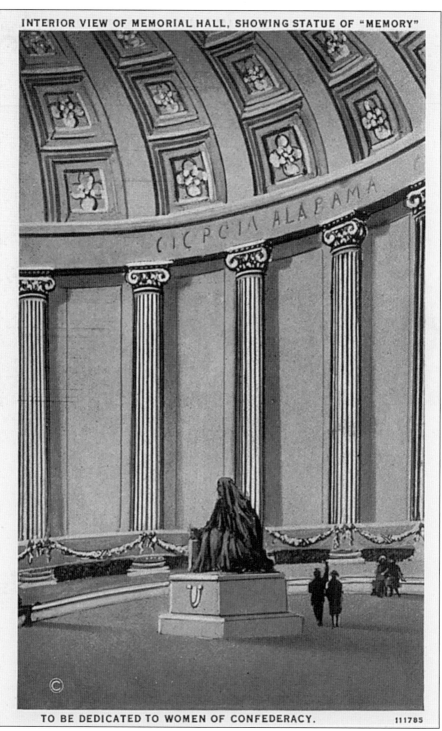

GEORGIA ALABAMA

TO BE DEDICATED TO WOMEN OF CONFEDERACY. 111785

Another drawing shows the planned interior of Memorial Hall. This section was to have been carved out of the interior of the mountain, and the granite sculpture entitled *Memory* was to have been dedicated to the women of the Confederacy.

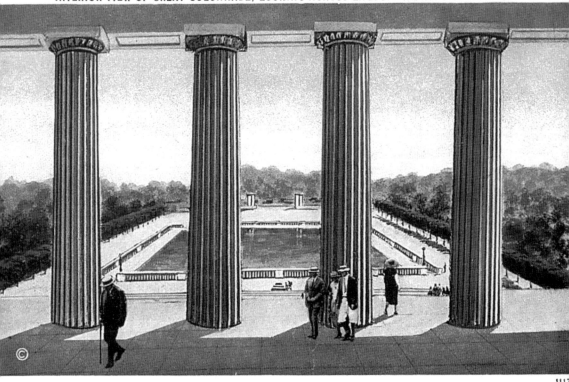

This drawing shows the reflecting pool and colonnade to be built on the summit of the mountain.

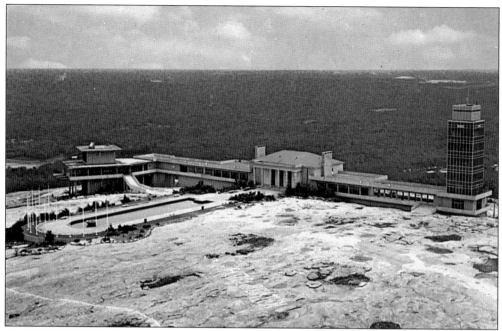

A view from above Stone Mountain shows the completed buildings, tower, and reflecting pool located on top of the mountain, as well as the surrounding suburbs of Atlanta.

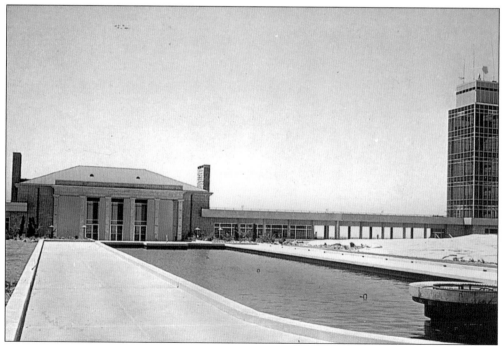

A photograph taken from the top of the mountain provides a closer view of the reflecting pool and tower.

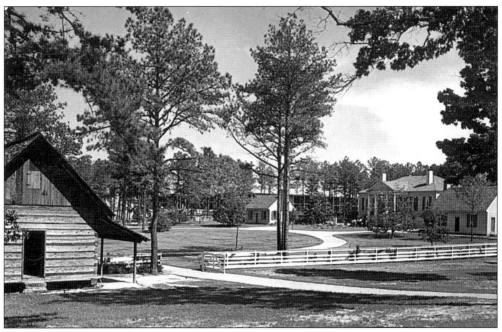

Visitors to Stone Mountain can tour the antebellum plantation located within the park grounds.

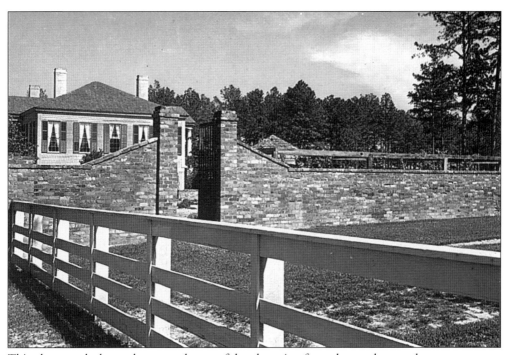

This photograph shows the manor house of the plantation from the rear barnyard.

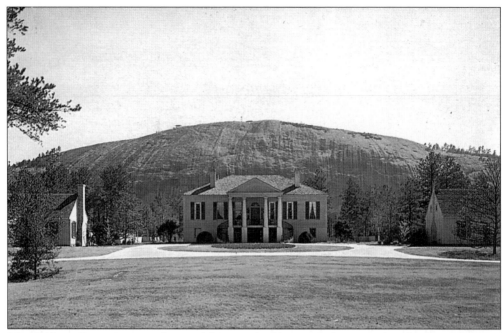

The Dickey House is one of several historic buildings on the grounds of Stone Mountain Park. With the mountain in the background, this structure makes a striking addition to the antebellum plantation.

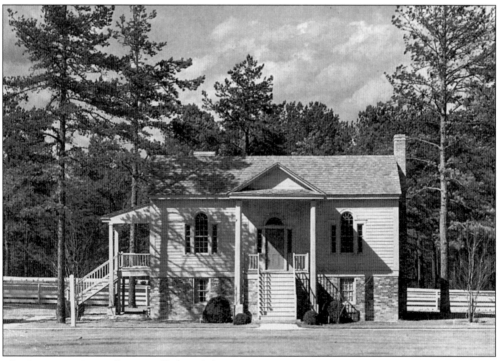

The Simpson House, known affectionately as "Jeannie's House," is another building featured in the antebellum plantation at Stone Mountain Park.

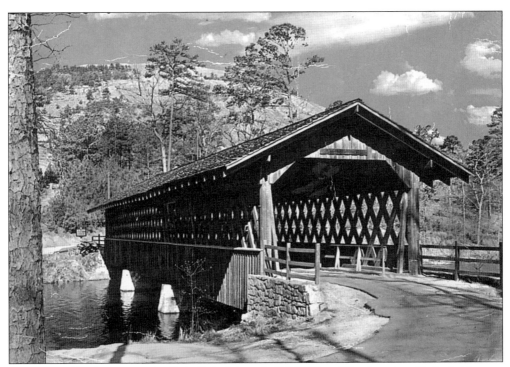

This covered bridge was originally built in Athens by W.W. King. Like the gristmill, the bridge was moved to Stone Mountain to become part of the park's collection of historic sites. The last known covered bridge original to DeKalb County was located on Panola Road.

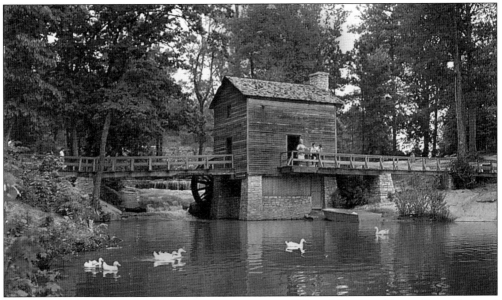

Originally built in the North Georgia mountains near Ellijay, this gristmill was dismantled and transported to Stone Mountain Park. At the new site, the mill was carefully rebuilt and restored to working order as one of the park's historical buildings. In the 1870s, DeKalb County had a number of working gristmills within its borders.

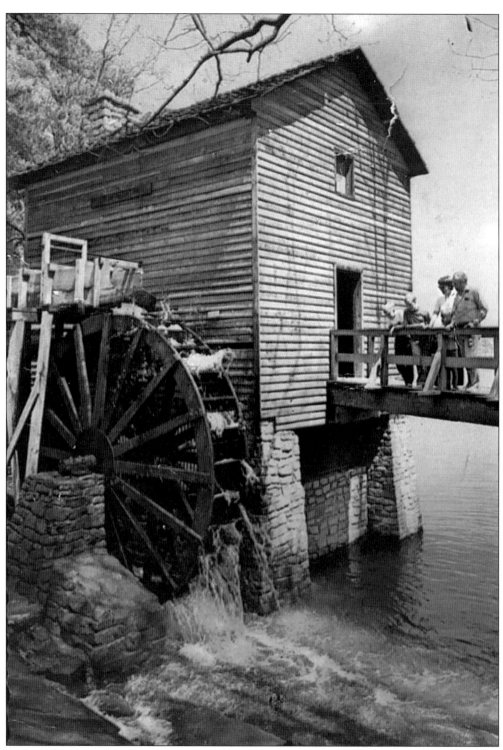

A view of the grist mill from the other side shows the water wheel, which is approximately 13 feet in diameter and revolves at a speed of 20 cycles a minute.

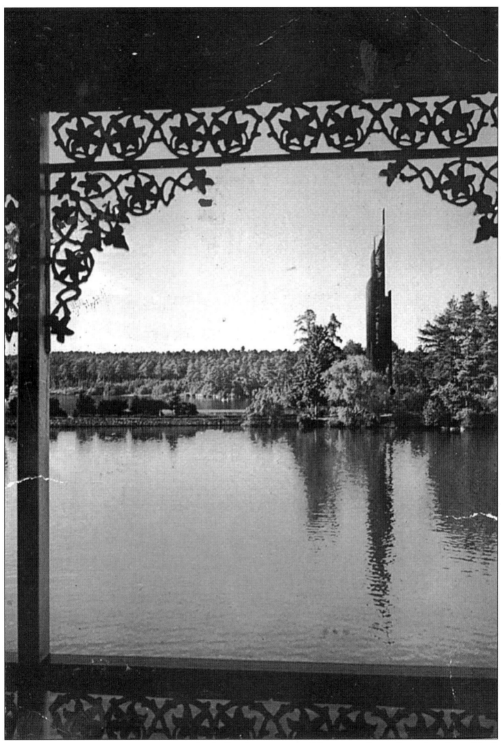

The Carillon at Stone Mountain was built for the 1964 World's Fair. The redwood and steel bell tower is 13 stories tall and features 732 bell tones.

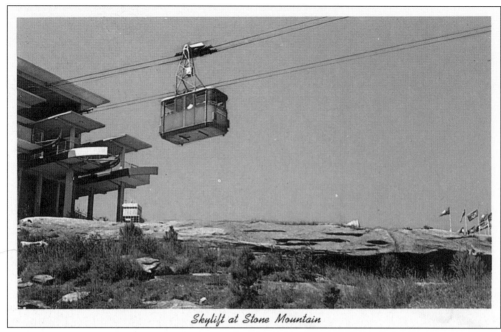

Skylift at Stone Mountain

Visitors to Stone Mountain Park often hike up the side of the mountain and ride the skylift from the top back down to the ground.

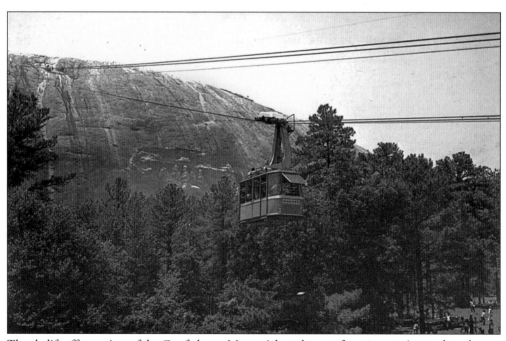

The skylift offers a view of the Confederate Memorial on the way from one station to the other.

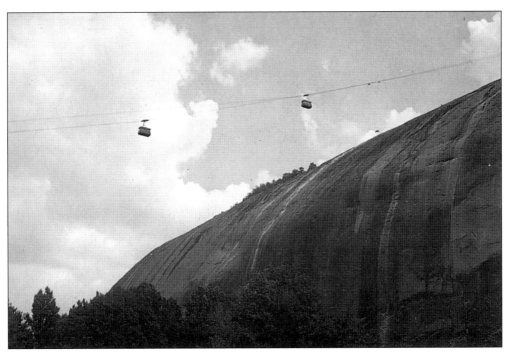

As shown in this photograph, the trip, which is made in small "buckets" over a cable thousands of feet long, is not for the faint of heart.

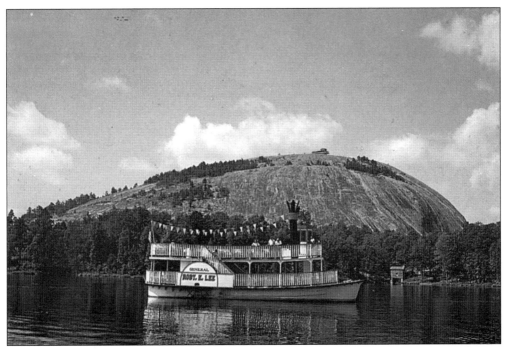

Visitors to Stone Mountain Park often enjoy a ride on the *General Robert E. Lee*, a paddlewheel showboat that traverses the park's lake. Other fun activities include renting paddleboats, relaxing on the beach, and riding the water slides in the small water park.

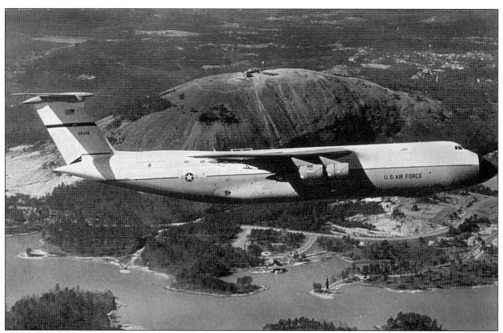

This photograph shows a recent aerial view of the entire park, which covers over 3,000 acres. The caption on the reverse side of this postcard reads, "World's Largest Airplane, World's Largest Rock."

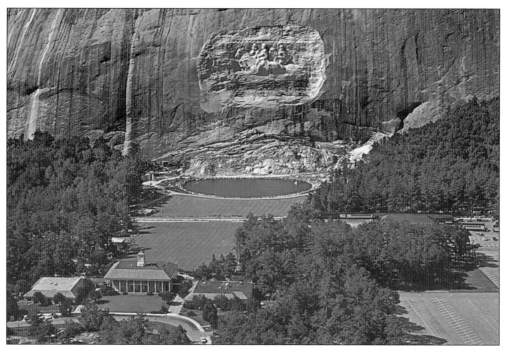

This recent view of the Stone Mountain Park complex shows the finished memorial and commemorative buildings. The Stone Mountain Scenic Railroad is visible, cutting through the grassy expanse underneath the memorial on its way around the mountain's base.

Six

MILITARY LANDMARKS

Built in 1917 as a training camp for soldiers during the First World War, Camp Gordon was named for Confederate general John Brown Gordon. Located in the City of Chamblee, the Camp Gordon site remains an important piece of DeKalb's history. Lawson Hospital was built on this site and served as "the hospital" for those needing prosthetics during and after the war. Currently, the former naval airfield is used as a commercial and private aviation center.

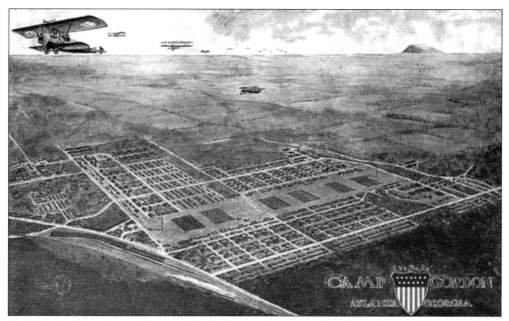

A 1918 aerial depiction of the newly built Camp Gordon in Chamblee shows early aircraft flying high above the two-mile-square camp, whose 1,200 buildings were home to some 40,000 men. Peachtree Road runs across the bottom left quadrant of the picture, and Stone Mountain can be seen in the upper right corner.

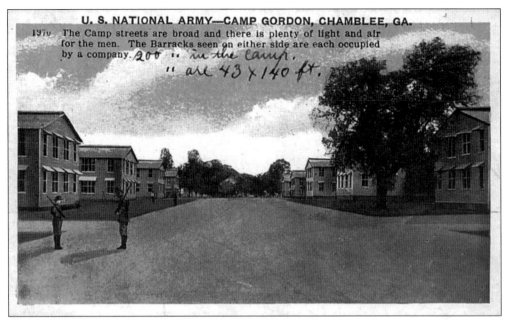

U. S. NATIONAL ARMY—CAMP GORDON, CHAMBLEE, GA.

1970 The Camp streets are broad and there is plenty of light and air for the men. The Barracks seen on either side are each occupied by a company. 200 *in the camp.* *are 43 x 140 ft.*

As this postcard proclaims, the Camp Gordon barracks were the epitome of modern military accommodations. Two hundred barracks, each measuring 43 by 140 feet, housed the soldiers, and the camp as a whole was spacious and comfortable.

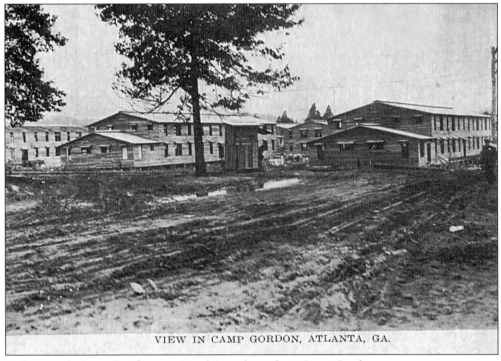

VIEW IN CAMP GORDON, ATLANTA, GA.

A photograph shows the aforementioned Army barracks at Camp Gordon.

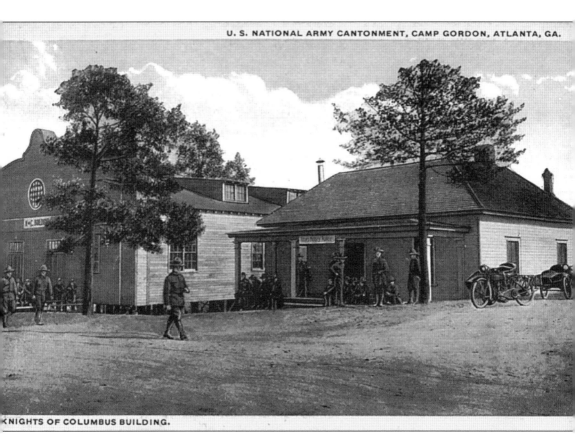

KNIGHTS OF COLUMBUS BUILDING.

The multi-windowed Knights of Columbus building is shown next to the smaller home of the military police. To the right of the police building are several early motorbikes.

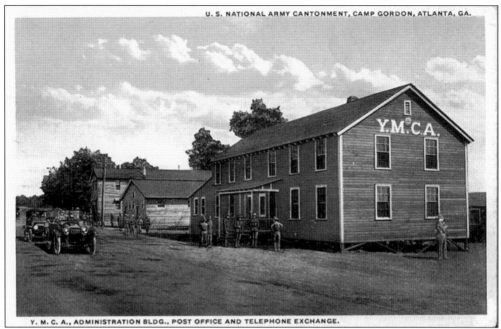

Y. M. C. A., ADMINISTRATION BLDG., POST OFFICE AND TELEPHONE EXCHANGE.

The Camp Gordon YMCA Administration Building is shown here in the foreground. To the left of the YMCA building is the camp post office, and at the far left is the telephone exchange. Automobiles pass by on the main road, which runs alongside of the buildings.

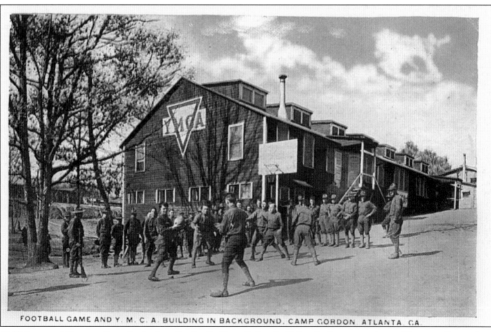

FOOTBALL GAME AND Y. M. C. A. BUILDING IN BACKGROUND, CAMP GORDON ATLANTA GA

Off-duty soldiers enjoyed playing basketball and football in their spare time. Shown above is a group of men playing football in front of the YMCA building, the site of many informal games.

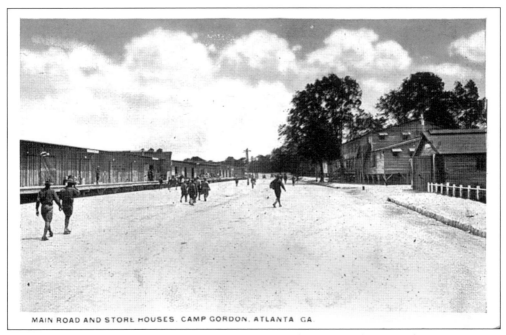

MAIN ROAD AND STORE HOUSES. CAMP GORDON. ATLANTA GA.

This wide avenue was the main route through the heart of Camp Gordon, providing easy access to and transport of supplies from the storehouses lining the side of the road to other areas of the camp.

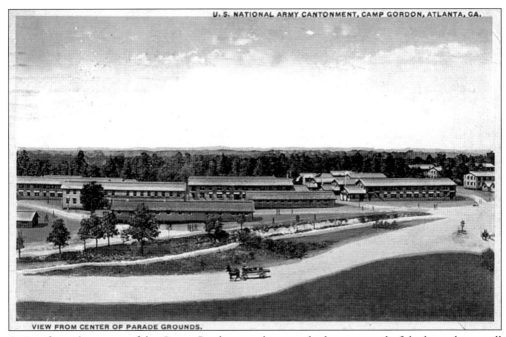

U. S. NATIONAL ARMY CANTONMENT, CAMP GORDON, ATLANTA, GA.

VIEW FROM CENTER OF PARADE GROUNDS.

A view from the center of the Camp Gordon parade grounds shows several of the barracks as well as the main road through the camp.

97

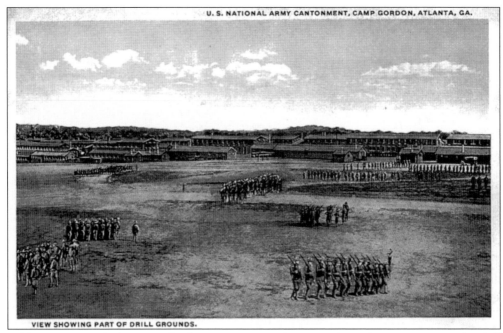

VIEW SHOWING PART OF DRILL GROUNDS.

Soldiers, some in formation and others at ease, wait their turn for military training on the drill grounds at Camp Gordon.

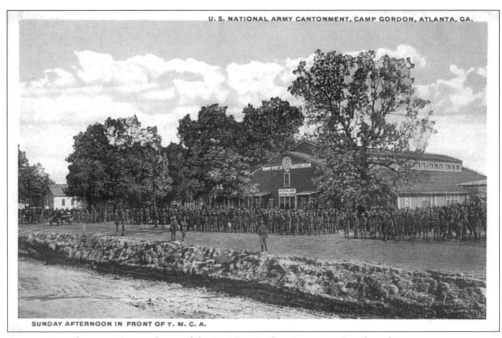

SUNDAY AFTERNOON IN FRONT OF Y. M. C. A.

Companies of men gather in front of the YMCA Auditorium on a Sunday afternoon.

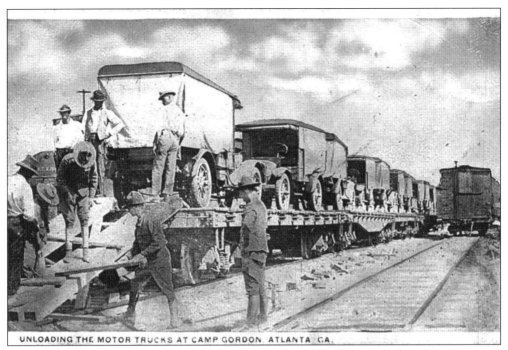

UNLOADING THE MOTOR TRUCKS AT CAMP GORDON, ATLANTA, GA.

Trucks and supplies arrived at Camp Gordon by train. Southern Railway and Georgia Electric Railway trains stopped at Camp Gordon, bringing trucks, food, and other necessities to the site twelve miles from Atlanta.

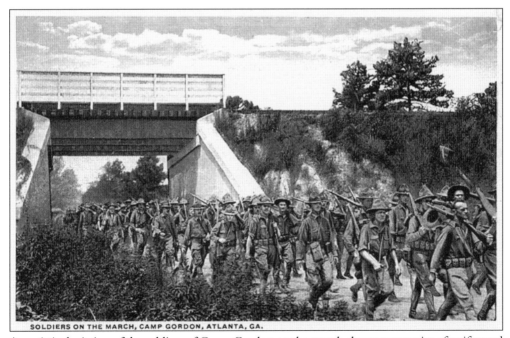

SOLDIERS ON THE MARCH, CAMP GORDON, ATLANTA, GA.

An artistic depiction of the soldiers of Camp Gordon on the march shows companies of uniformed men passing under a railroad trestle.

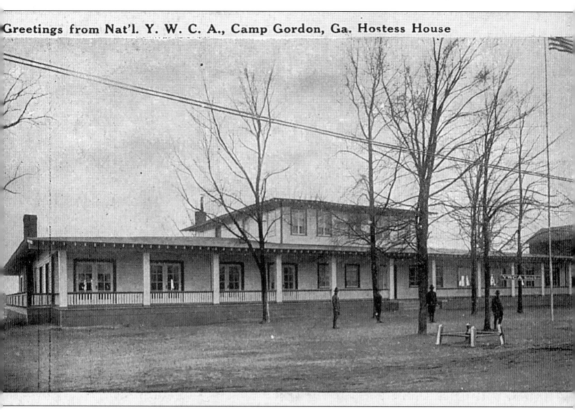

The Camp Gordon Hostess House was the site of many military social functions.

Seven
HELPING HANDS

DeKalb County is home to many charitable homes and hospitals funded by the church, the state, and the military. While many of these institutions still exist, some, such as Lawson General Hospital, do not. The Scottish Rite Hospital building does remain but the hospital relocated to Fulton County after a merger with Egleston Children's Hospital.

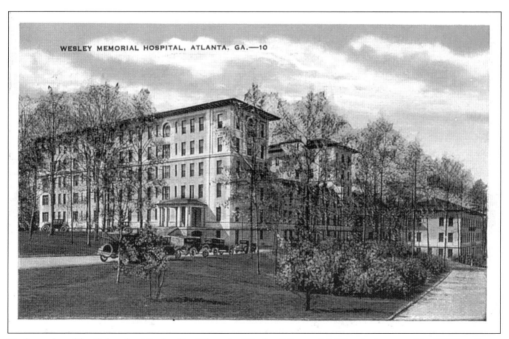

Endowed and built by the Methodist Church, Wesley Memorial Hospital opened in 1905 and was originally located in downtown Atlanta before moving to DeKalb.

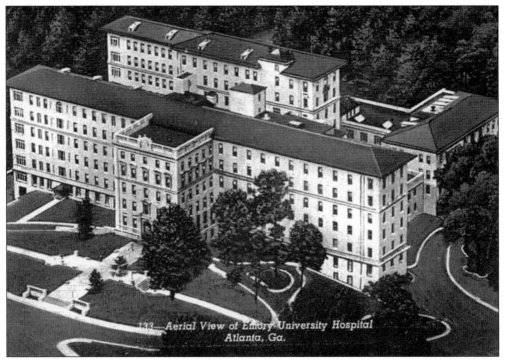

133—Aerial View of Emory University Hospital
Atlanta, Ga.

In 1922, Wesley Memorial Hospital moved to the Atlanta campus of Emory University and was renamed Emory University Hospital. Shown here are two aerial depictions of the Emory University Hospital. The terra cotta roofing and marble walls match the academic buildings on the Emory University campus, and the hospital is part of the school's medical program.

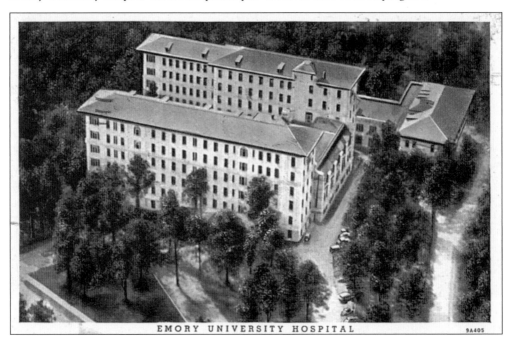

EMORY UNIVERSITY HOSPITAL

9A405

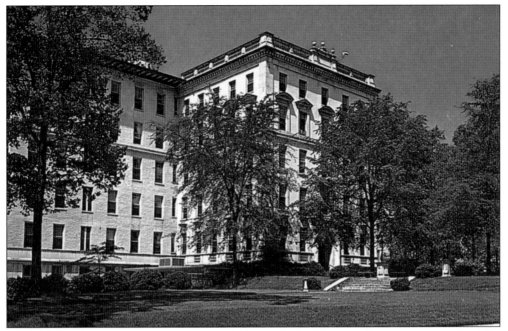

A photograph of Emory University Hospital shows the building much as it appears today. The building has been enlarged and updated during the 80 years it has stood on Clifton Road. The hospital remains a landmark of the Druid Hills area and an integral part of Emory University.

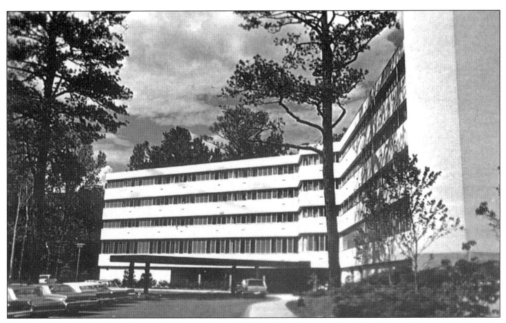

Wesley Woods Health Center is located on Clifton Road, several miles from Emory University Hospital. Long affiliated with the hospital system, Wesley Woods provides its residents with extended-care nursing.

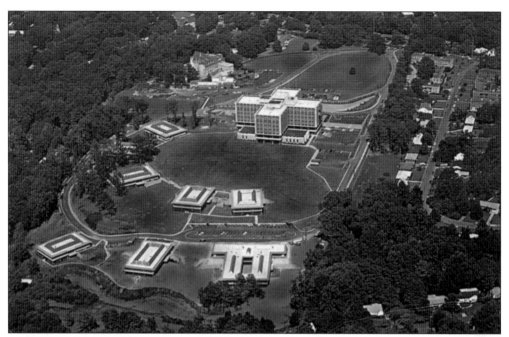

The National Centers for Disease Control (CDC) is also located on Clifton Road near Emory University Hospital. The Atlanta-based CDC assists public health services in preventing and controlling communicable and infectious diseases throughout the United States.

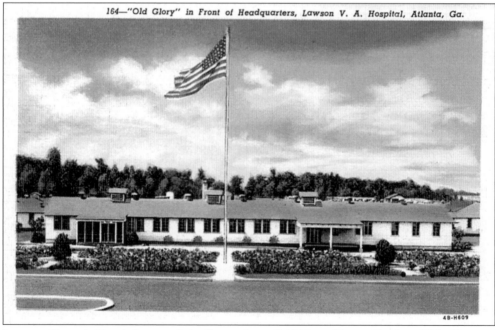

164—"Old Glory" in Front of Headquarters, Lawson V. A. Hospital, Atlanta, Ga.

Lawson General Hospital opened in September of 1946 at Camp Gordon. This Veterans Administration hospital was named for Thomas Lawson, surgeon general to the U.S. Army from 1836 to 1861. After the renovation of the Atlanta VA Hospital in 1952, Lawson was deactivated.

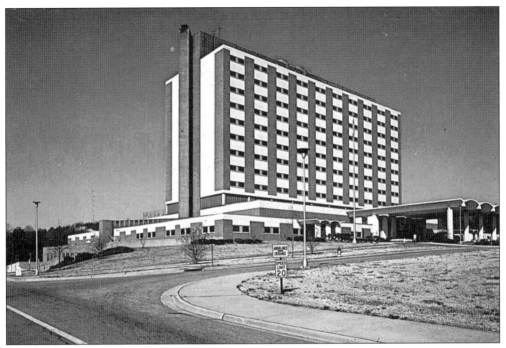

Built in 1967, the Veterans Administration Hospital is located on Clairmont Road near Emory University Apartments. The facility has an extensive outpatient program and is affiliated with the Emory University School of Medicine.

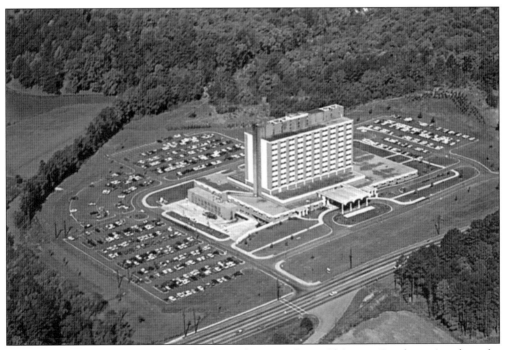

An aerial view of the VA Hospital and surrounding area shows Clairmont Road running along the bottom right hand corner.

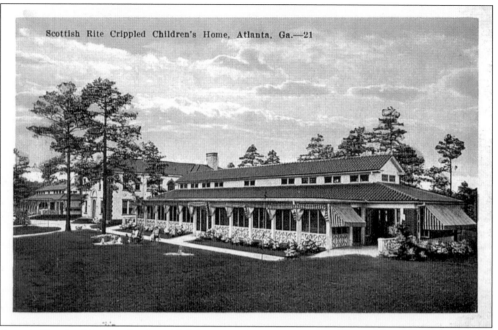

Founded by the Masons, the Scottish Rite Convalescent Hospital for Crippled Children opened in Decatur in 1915. In 1919, a new 50-bed facility was built and renamed the Scottish Rite Hospital for Crippled Children.

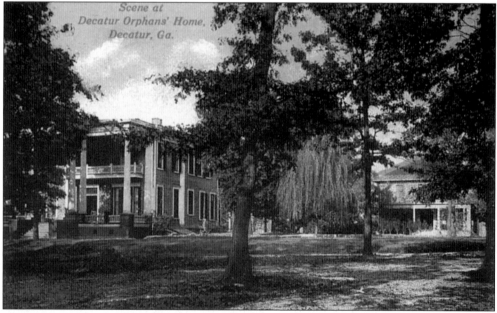

The Decatur Orphans' Home was built in 1873 by the Methodist evangelist Rev. Sam P. Jones and provided housing and education for hundreds of children. When in 1934 it became evident that many of the children served by the home were not, in fact, orphans, the organization was renamed the Methodist Children's Home. Called the United Methodist Children's Home since 1970, the campus is currently located on South Columbia Drive in the City of Decatur.

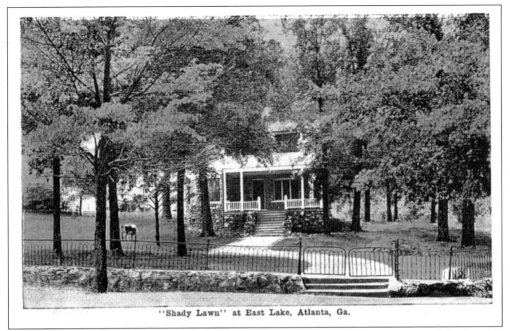

"Shady Lawn" at East Lake, Atlanta, Ga.

Located in East Lake, Shady Lawn was the receiving home for temporary care of the Georgia Children's Home Society's wards. Children remained here until the society found suitable permanent homes in private family households.

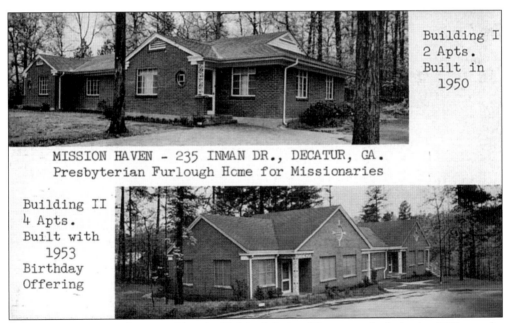

Building I
2 Apts.
Built in
1950

MISSION HAVEN - 235 INMAN DR., DECATUR, GA.
Presbyterian Furlough Home for Missionaries

Building II
4 Apts.
Built with
1953
Birthday
Offering

Sponsored by the Presbyterian Church, U.S.A., Mission Haven was built in the 1950s on the campus of Columbia Theological Seminary. The two structures provide housing for missionary families while on furlough.

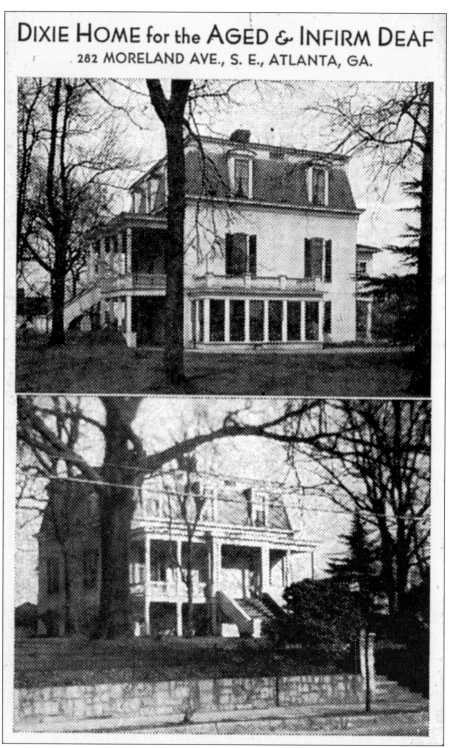

DIXIE HOME for the AGED & INFIRM DEAF
282 MORELAND AVE., S. E., ATLANTA, GA.

The Dixie Home for the Aged and Infirm Deaf was located on Moreland Avenue near the DeKalb/Fulton County border.

Eight
SOCIETY

Whether members spent their time exercising or catching up on the latest community news, social clubs have flourished in DeKalb County over the past 100 years. Druid Hills and East Lake both underwent extensive renovation in the 1990s and both remain important to the county's social scene.

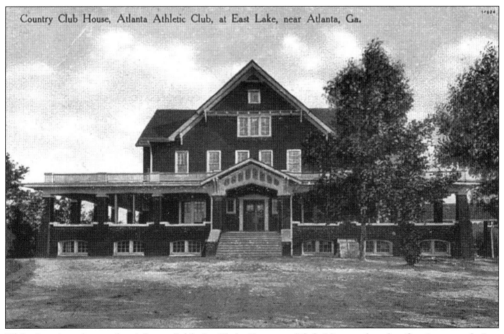

This drawing shows the Atlanta Athletic Club Country Club House shortly after its completion in 1908.

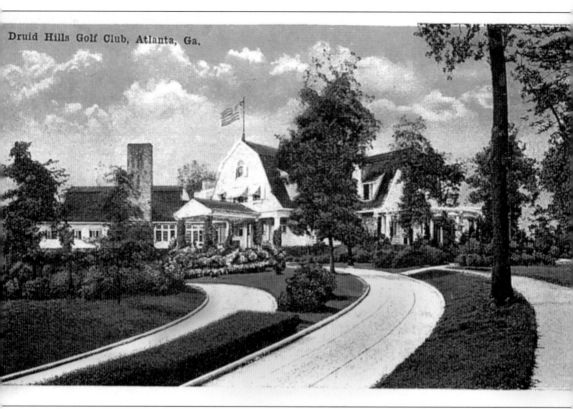

Druid Hills Golf Club, Atlanta, Ga.

Located at the intersection of Ponce de Leon Avenue and Clifton Road, the Druid Hills Golf Club was founded in 1912.

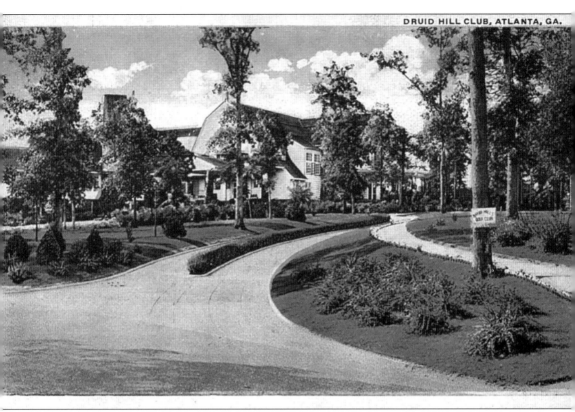

The Druid Hills Golf Club has hosted the Dogwood Invitational Tournament and was the site of golfer Bobby Jones's Club Championship victory at the tender age of 14.

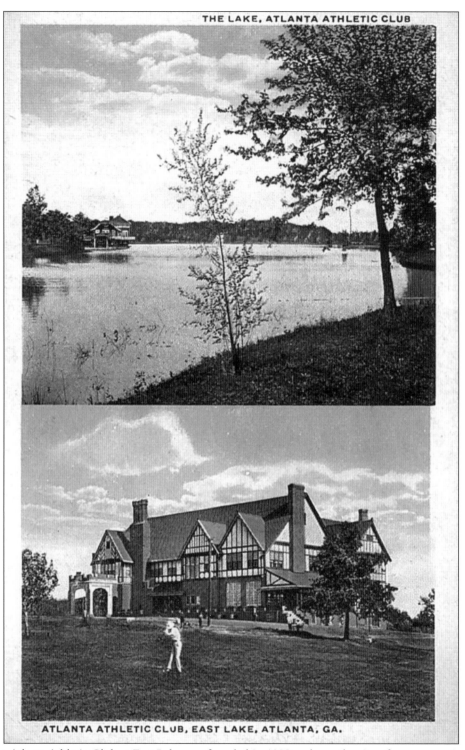

ATLANTA ATHLETIC CLUB, EAST LAKE, ATLANTA, GA.

The Atlanta Athletic Club at East Lake was founded in 1908 and was the site of many prominent golf championships. Shown here are the lake and clubhouse of the Atlanta Athletic Club.

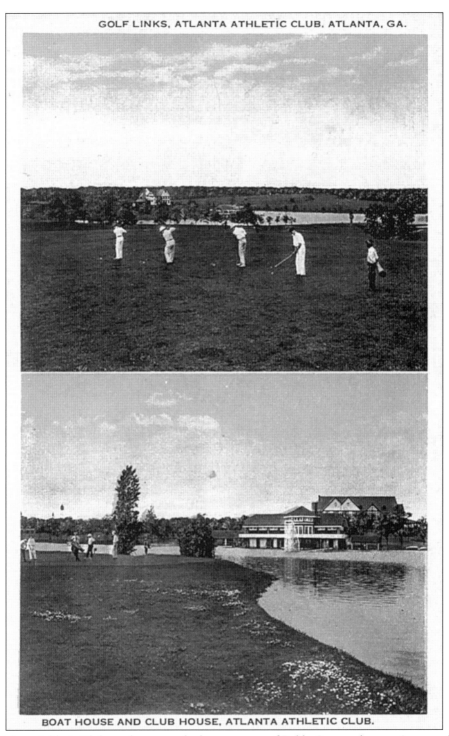

GOLF LINKS, ATLANTA ATHLETIC CLUB, ATLANTA, GA.

BOAT HOUSE AND CLUB HOUSE, ATLANTA ATHLETIC CLUB.

The Atlanta Athletic Club was known as the home course of Bobby Jones, who was six years old at the time of its grand opening and later served as president from 1946 to 1947. Shown here are the links and the boathouse of the club.

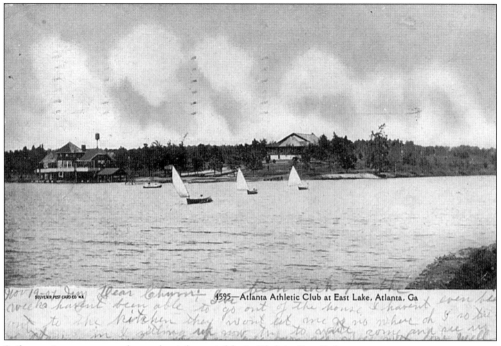

Sailors enjoy a summer day at the Atlanta Athletic Club in East Lake.

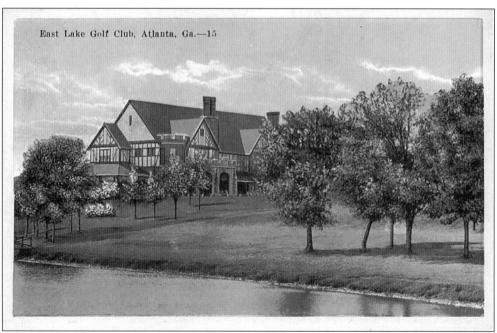

An artistic depiction shows the stately Atlanta Athletic clubhouse labeled as the East Lake Golf Club. The Atlanta Athletic Club moved to Duluth during the "white flight" and urban decay of the 1960s, and the clubhouse was sold and renamed East Lake in 1968.

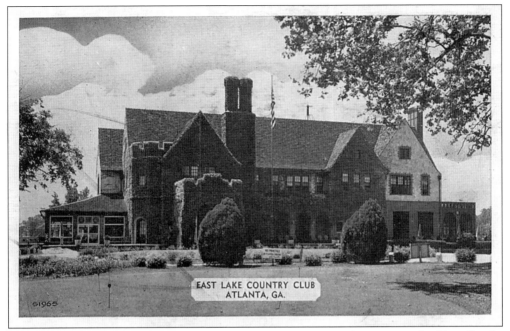

The East Lake Country Club remained a popular destination for Decatur families after its conversion in 1968.

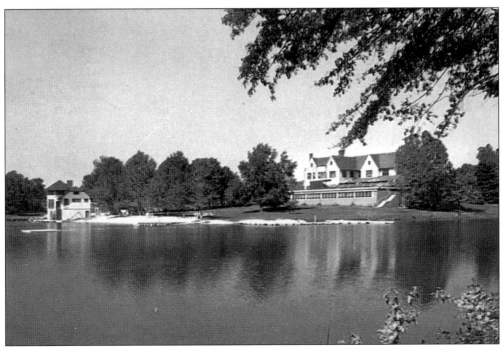

A photograph shows the East Lake Golf Club docks and clubhouse. The East Lake area has experienced much positive growth over the past decade, and the East Lake Country Club now serves as the driving force behind community revitalization efforts.

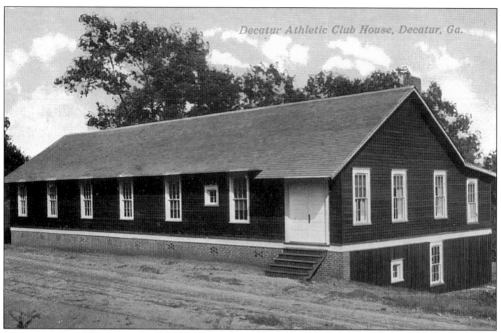

These two drawings show the Decatur Athletic Club tennis courts and clubhouse.

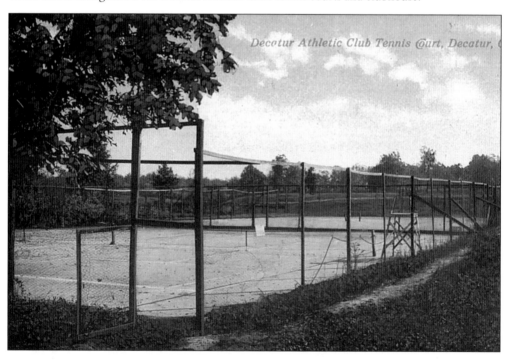

Nine

FACES

While for the most part unidentified, these picture postcards from the DeKalb Historical Society's Jeannette Sheffield papers reveal long-ago faces of DeKalb County as collected by a DeKalb resident.

An unidentified little boy with an unusual form of transportation appears in this postcard.

An unidentified man is seen at a studio fence in the postcard above.

"Mrs. Harry S. Newman" poses for this postcard view.

This postcard depicts "Miss Pearl Stanley."

An unidentified man with a diamond tie is seen in the postcard above.

"Miss Grace Royal" relaxes on a swing in this posed postcard image.

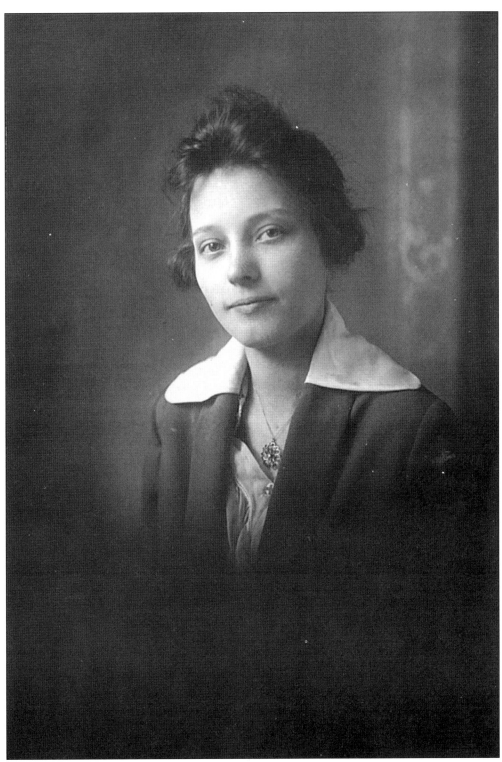

An unidentified woman with a filigree necklace appears in this postcard.

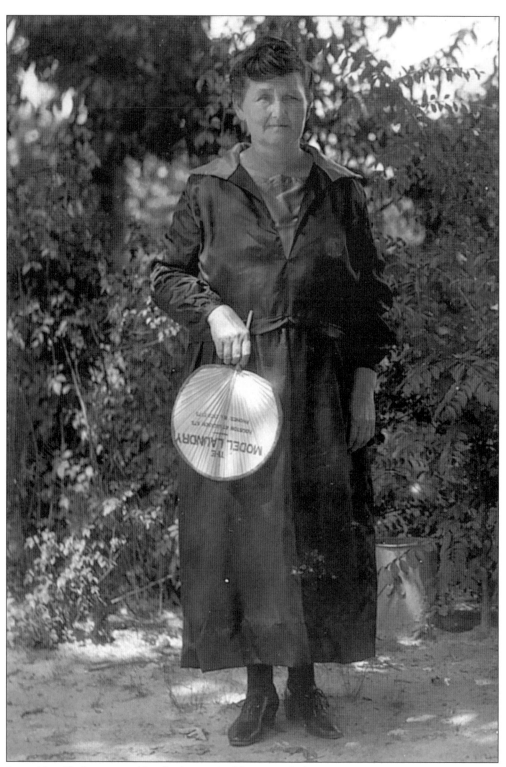

An unidentified woman with a fan is seen in this postcard view.

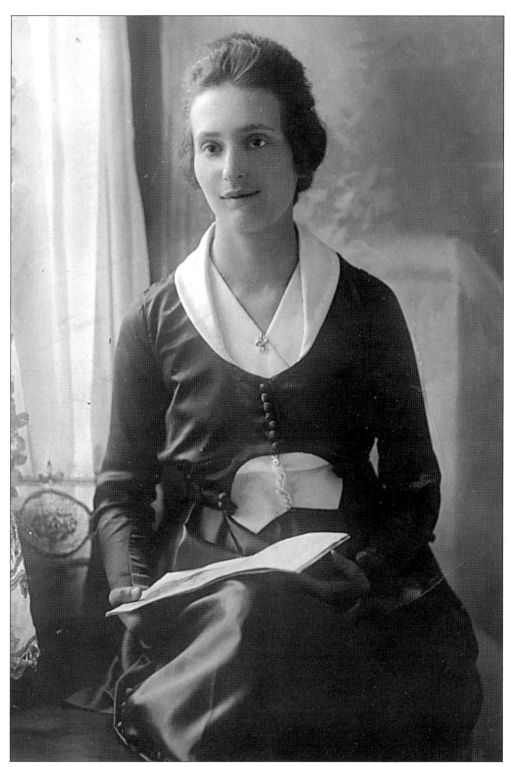

The unidentified woman here is shown sitting in a chair with a paper in hand.

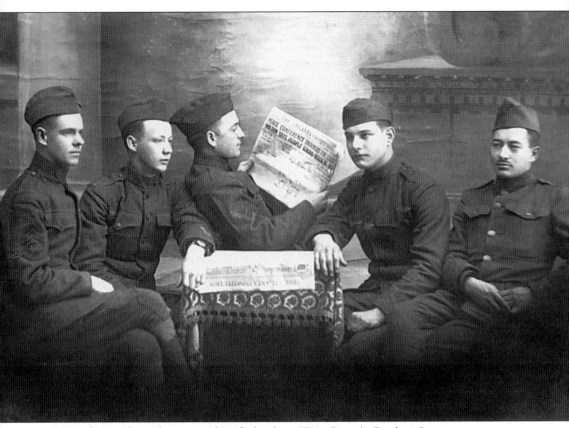

These five uniformed men are identified only as "Five Georgia Crackers."

Miss Cherie Stephens served as Miss DeKalb County in 1968–1969.

RESOURCES

The fascinating history behind these postcard images can be found in the archives and collections of the DeKalb Historical Society. Founded in 1947, the DeKalb Historical Society contains a research library and a six-room museum. The society maintains the Old Courthouse on the Square as well as a three-building historic complex that includes the 1830s Swanton House as well as the Biffle and Barber Cabins. For more information on scenes from the postcards or for additional reading about DeKalb County's history, contact the DeKalb Historical Society.

Clarke, Caroline McKinney. *The Story of Decatur 1823–1923*. Fernandina Beach, Florida: Wolfe Publishing, 1995.

Garrett, Franklin. *Atlanta and Its Environs: A Chronicle of Its People and Events*. New York: Lewis Historical Publishing Co., 1954

Matthews, Antoinette Johnson. *Oakdale Road*. Atlanta, Georgia: Atlanta Historical Society, 1972.

Owens, Sue Ellen. *Timeline of DeKalb, 1822–1999*. Decatur, Georgia: DeKalb Historical Society, 2000.

Price, Vivian. *The History of DeKalb County, Georgia, 1822–1900*. Fernandina Beach, Florida: Wolfe Publishing, 1997.